Community

Hist

Pł          Res

# 1860–1945

## Robert Pols

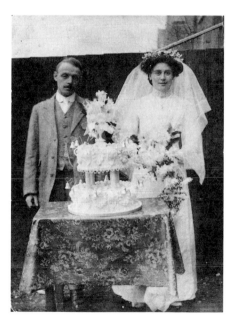

PUBLIC RECORD OFFICE

Public Record Office Publications
Kew
Richmond
Surrey
TW9 4DU

www.pro.gov.uk/

ISBN 1 903365 20 1          **08733551**

A catalogue record for this book is available from the British Library

Front cover: see picture details on pp. 28, 50, 66, 97, 106
Back cover: see picture details on p. 4

Picture credits: Figures 38, 58, 74, 101, 105, 109, 111, 116, 117, 118, 119,
122, 125, 126 are from the Public Record Office. While every effort has
been made to trace copyright holders, this has not always proved possible
because of the antiquity of the images. All other illustrations are from the
author's private collection.

Printed in the United Kingdom by St Edmundsbury Press,
Bury St. Edmunds, Suffolk.

# Contents

# Acknowledgements

I am grateful to Sheila Knight of the PRO for her patient guidance, to Deborah Pownall for her enthusiastic picture research, to Peter Leek for his detailed and helpful suggestions, and to Max Tyler, historian of the British Music Hall Society, for his illumination of the career of Victoria Monks. My thanks go, too, to my wife, Pam, for reading and discussing the text, and for responding to my constant requests for her thoughts on this or that photograph that I thrust before her.

# List of Illustrations

# 1 A Sense of Wonder

We live in an age of wonders. Digital technology, biochemistry, space exploration and a plethora of television channels queue up to amaze us. We are inundated with innovations and stuffed with the stupendous. So, replete with marvels yet ever hungering for more, we may find it easy to take for granted those things which inspired earlier generations. But they had their wonders, too.

Take the Victorians, for instance. Their age, just like any other, had its squalor, its injustices, its deprivations, its vanities, its meanness. But it also had its discoveries and inventions, and it is probably fair to argue that none of them has had as much impact on our view of ourselves as photography. Suddenly it became possible to capture and preserve an image of a human being at a moment in time. It wasn't a painting, laboured over for days, dependent on the artist's skill and interpretation, and vulnerable to charges of visual infidelity. The result may not always have pleased, but it was incontrovertibly real, a few seconds of stillness caught and handed over for taking home. It is sad if we no longer find this wonderful.

Certainly our ancestors did. Inevitably there were those whose raptures were distinctly modified. In London, *The Spectator* grumbled that these new pictures were unflattering to the point of being disagreeable; and *The Corsair* of New York wondered if people really wished to preserve for public scrutiny those less presentable moments that had previously been kept as a secret between individual and mirror. But delight was the more usual reaction and Henry Fox Talbot, the creator of the calotype process, summed up a common feeling when he argued 'It is a little bit of magic realized – of natural magic.' The Victorians fell in love with photography, and their love lasted (Figure 1).

Consider Mr Cox, who went one day in August 1862 to an unidentified London photographer to have his portrait made (Figure 2). Photography was already over 20 years old, but until very recently its cost had tended to restrict it to the better-off. Now cartes de visite, small paper photographs mounted on card, had made a studio visit much cheaper and increasingly popular. The first such pictures in London had appeared at the end of the 1850s, but it was the appearance of the royal family on cartes de visite in 1860 that provided the impetus needed for complete lift-off. It is not known whether Mr Cox had been photographed before, but on this

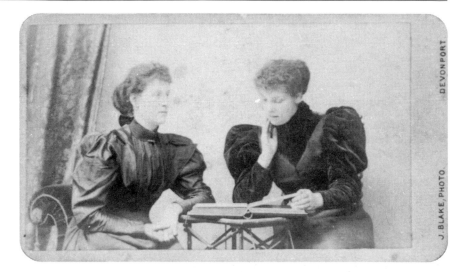

**Figure 1** Novelty format; J. Blake, Devonport

particular summer's day he was intending to follow in royal footsteps and have his image recorded on a carte.

So he presented himself at the studio in his frock coat, a shirt so white that it would burn out any detail on the photographic plate, a well-brushed top hat and nicely polished shoes. He carried a stick that was thin enough to be elegant, but knurled enough not to be effete. He was carefully posed by the photographer: each hand was given something to do, and it is possible that his hair was thoughtfully arranged to counter any suspicion that it was receding. It was going to be necessary for him to keep absolutely still during an exposure of quite a few seconds, so the photographer provided a little help from behind in the form of a head clamp or rest, the base of which could not be entirely concealed by the subject's feet.

The resulting portrait seems likely to have pleased, for it shows Mr Cox standing upright and steady, well-dressed and respectable. His gaze is direct, his jaw square, and his expression manly and sober, though not too severe. He could be about to speak, and who can doubt that his words would be measured and wise? He is a man to be taken seriously, and to emphasize the fact he is shown in a setting of dignity. Behind him, flanked by a heavy curtain, is a massy (though painted) column, on the plinth of which is depicted a warrior on a noble steed which is being attacked by, I think, a lion. We may perceive a lack of balance between the plainness to his left and the massed architecture and soft furnishings to his right. We may carp that the key vertical of the background grows out of the subject's head. We may suspect that the virile associations of martial vigour are a

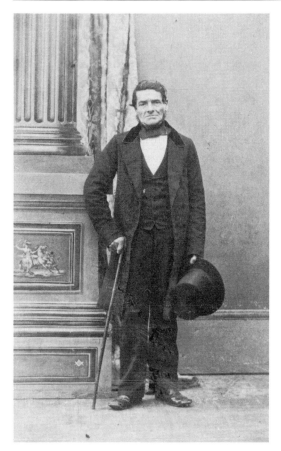

**Figure 2** Carte de visite;
photographer unknown

shade undermined by the fact that the horse-borne warrior appears to be
an Amazon. Nevertheless, the photograph does its job. It projects just the
kind of image that Mr Cox, and thousands like him, would have wished.
He comes over as a man of solidity and substance, and the portrait must be
accounted a success.

Consider, too, Emma and Kate King, who in the same year also sat for a
carte de visite (Figure 3). They went through the same ordeal of keeping
still, though their crinolines provided useful cover for any steadying
devices that were used to assist them. Their hands have been occupied
quite effectively. The hat-holding is natural enough, and the left hand of
the older girl, resting on her leg, looks relaxed. The younger girl's hand on
the other's shoulder may possibly speak of a need for reassurance as well
as of sisterly warmth, but it's a very agreeable picture. Again, an image is
projected. The girls are self-contained and still, and their unsmiling
demeanour suggests a maidenly coolness that was entirely proper. They,
too, had every reason to be satisfied with their picture.

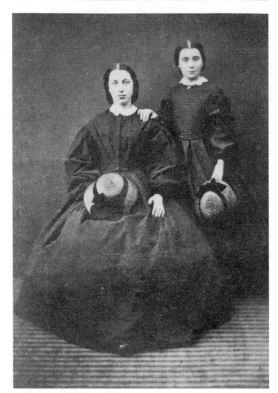

**Figure 3** Carte de visite;
photographer unknown

Indeed, if these photographs represent the first trip to a studio for Mr Cox or the Misses King, they may have been rather more than satisfied. To hold for the first time a portable image of yourself must have been epiphanic. It was an image that was unmistakable yet slightly disturbing, for in mirrors we are used to seeing ourselves reversed. It was an image which continued to be there, even when you stopped looking at it. Photography really was rather wonderful.

But the pictures that entranced our forebears can be a revelation to us as well. We can share their fascination with them as products of the action of light. Then we can admire what light has drawn, enjoying the self-images the portraits convey and, in the examples before us, noting the contours of Mr Cox's knuckles and the texture of the Misses King's straw hats. We might well feel that the quality of the pictures deserves our respect. The photographic emulsion may not have been able to handle any refinements of white in Mr Cox's shirt, but it has dealt admirably with the gradations of dark colour, keeping the garments distinct from each other, picking out the creases in sleeves and waistcoat, and showing up the trimming on the coat collar. The younger Miss King may be in slightly less sharp focus than her sister (for she is a little further from the camera, and early lenses had

their limitations), but the resulting softness becomes her. Here, too, there are fine variations of rich darkness, against which glow hats, hands, collars, faces and partings. Most of us have taken far worse pictures with much more advanced equipment.

There is something remarkable, too, in the sheer robustness of these pictures. Each is on a flimsy piece of paper which has, in the course of processing, been soaked in at least three concoctions of chemicals before being pasted on a slip of card. Then it has survived for close to a century and a half. It was made when Palmerston was Prime Minister and while the Americans were busy fighting the Civil War. Yet here it is today, just about as good as new, and offering us an eye-to-eye view across the years to the century before last.

That, of course, brings us to the topic of history and to the concerns of family historians. The family album brings us face to face with our ancestors; these are the faces of our own unremembered past. This is where we confront our gene bank, and where the question 'Who are they?' is disturbingly linked to the question 'Who am I?'. After making his first survey of a display of photographs, Walt Whitman observed: 'There is always, to us, a strange fascination in portraits. We love to dwell long upon them – to infer many things from the text they preach.' Never is this more true than when the faces they show represent our own family past.

You may be a researcher, already well versed in the arcana of your study, or the slightly bemused inheritor of a box or album of old pictures of which you are trying to make some sense. In either case, your photographs represent a window into the world of ancestors, and your prime aim will be to interpret the view.

Often, the first problem posed by an old picture is deciding who it represents. Our predecessors tended to be no better than we are at documenting their collections of photographs. No book can offer to distinguish any one person's great-great-grandmother from her younger sister or her daughter. But it can help with deciding when a picture was taken, and that can narrow the possibilities enormously. Fortunately, many old photographs are surprisingly datable. It is usually possible to identify the decade, and greater precision is often achievable. One aim of this book is to help the reader to place a family photograph in time. It concentrates, therefore, on pictures of people, and it extends in treatment as far as the Second World War.

It is a pity, though, if family historians limit their concern to dating. There is so much more information and enjoyment that can be extracted from many photographs. It may be possible to understand a picture's place in photographic history and to appreciate something of what went into its creation. A picture may tell us about its maker and about the studio where it was taken. It may seek to convey an image, showing how the subject wished to appear. We can increase the satisfaction that a picture gives by knowing more about it as an artefact, by understanding something about

its making, and by asking what it shows us of people, attitudes, social customs and tastes.

Quite simply, the more you understand, the closer you look; the closer you look, the more you find; and the more you find, the more you enjoy. Those are the propositions underlying this book.

# 2 The Technical Development of Photography

## Solving the basic problems

Early photographers thought of their art as drawing with light, and they had a point. The early history of photography is a record of attempts to manipulate the physical properties and chemical effects of light.

We register things, visually, by the light that is reflected from them. So when light bounces off an object, the beams that happen to bounce in the right direction enter the eye, meet the retina, and are interpreted by the brain as an image.

If light can thus carry messages to the screen we call a retina, it might reasonably be wondered whether it can carry messages to other kinds of screen. The answer, recognized in China at least as early as the 5th century BC, is that it can. When a manageable cluster of light beams is selected by being passed through a small hole (like the iris), an inverted image is formed on the screen beyond. Leonardo da Vinci understood the pinhole-image principle and described it in notebooks which were not deciphered for around 200 years. But the earliest published account dates from 1558, when Giovanni Battista della Porta recommended the camera obscura ('darkened chamber') as an aid to drawing.

The essence of the camera obscura is a closed room, where one interior wall has been painted white, and where a pinhole has been made in the wall opposite. On a suitably sunny day, a picture of the scene outside the pierced wall appears, upside down, on the white one. The introduction of a lens into the small hole opens up the possibility of turning the image the right way up, intensifying it and improving its definition. Mirrors could be used to direct the image from the white wall onto a sheet of paper for convenient tracing. What works for a room also works for a box; and once you have a box, you have something that is already recognizable as the camera we know. But unfortunately, although it can be traced, the actual image is dependent on the hole and the darkened space, so it can not be taken away from the box – or, rather, could not until the advent of photography.

Light was again the key, for it can have chemical effects on the surfaces it touches. The sun makes some things fade and other things darken, as

had been known ever since we noticed that it could bleach linen and tan skin. Formal investigation of the subject dates back to the work in the 1770s of the Swedish chemist Carl Wilhelm Scheele, who experimented with the darkening action of sunlight on silver chloride. But it was Thomas Wedgwood who made use of Scheele's observations to produce images. He explained, in a paper for the Royal Institution in 1802, how a piece of white paper or leather, moistened with a solution of nitrate of silver, would darken when exposed to light. The stronger the light, the quicker was the effect. But when he interrupted the passage of light and prevented it from reaching some parts of the prepared surface, he found that the shadowed areas did not darken. He had, in effect, learnt to make what are now known as contact prints. Unfortunately, as soon as the white areas were uncovered for viewing, they too started to darken, and the image was promptly lost. A method of washing away or neutralizing the silver salts was needed, if the picture was to be preserved.

The first person to find a way of creating a permanent picture was Joseph Nicéphore Niepce, who abandoned working with silver salts and experimented instead with bitumen of Judea, which both hardens and becomes paler in the light. When he exposed a bitumen-varnished pewter sheet in a camera, the areas that had been hit by the most intense light turned pale and hard, while the other areas, corresponding to the more shadowy parts of the projected image, remained soft. He then used a solvent to wash off the still tacky varnish, thereby exposing the darkish metal beneath. By 1827 he was able to produce pictures formed by a pattern of pale varnished patches and areas of bare pewter. It was a start, but since the exposure to light took around eight hours it was a rather hesitant one.

Nevertheless, it caught the imagination of Louis Daguerre, who entered into an alliance with Niepce, continued working beyond his partner's death, and eventually, in 1839, let it be known that he had created a method of reproducing and fixing an image. He, too, created his picture on a metal base, but his light-sensitive coating was not of resin. His method was to coat a copper plate thinly with silver, polish it highly, and then treat the surface with iodine to make it sensitive to light. After the plate had been exposed in the camera, warm mercury vapour was used to bring out the image. To stop this developing image growing ever darker, Daguerre at first used common salt.

The resulting photograph, called, not unreasonably, a daguerreotype, earned its inventor a pension from a grateful French government. It was actually a negative image, for the light areas of the original subject appeared dark on the silvered surface. But when it was held at the right angle to the light, a positive image appeared (just as can be found with a modern black-and-white negative), and that image was very sharply defined.

The earliest pictures required exposures of 10 minutes on a bright day, and much more in overcast conditions. This was not well suited to

portraits, and even scenery would not always keep still for long enough. Passing pedestrians and vehicles left a blur; or if they moved quickly enough, no record at all. Even the minute hands of church clocks posed problems. It was not long, though, before Daguerre's disciples, experimenting with possible accelerators, found that bromine would speed up the reaction of chemicals to light. With exposure times reduced to a minute or two in decent light, the daguerreotype portrait became possible (Figure 4) and a new industry, professional photography, was born.

Meanwhile, a different solution to the problems of producing an image had been developed by an English country gentleman, William Henry Fox Talbot. Impatient with his own indifferent drawing skills, he sought a system whereby 'it is not the artist who makes the picture, but the picture which makes itself'. He worked with paper, first brushing it with saline solution and then soaking it in a solution of silver nitrate. When objects of interesting and complex outline were placed on this sensitized paper and exposed to light, the visible parts of the paper darkened. The areas beneath the object were protected from the light, and therefore remained pale. Striking white-on-black silhouettes, or 'photogenic drawings', were the result.

When Fox Talbot exposed a sheet of this prepared paper in a camera, a negative picture appeared. The brighter areas of the original subject reflected light strongly onto the corresponding parts of the prepared paper and so darkened it. But little or no reflected light met those parts of the paper's surface which corresponded to the shadowed or darkly coloured areas of the subject, so they stayed more or less pale.

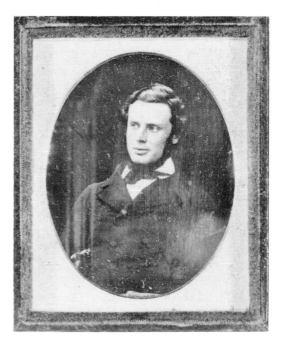

**Figure 4** Daguerreotype;
photographer unknown

The next step was to place this negative image over a second sheet of sensitized paper, allowing light to filter through the pale areas of the top sheet and to work on the sheet below. In this way, the negative effect was reversed and a recognizable positive image appeared. The fixing of such images was achieved by potassium iodide in the earliest experiments, and thereafter by salt solution.

Fox Talbot had, by his own account, been achieving some success as early as 1835, but it was Daguerre's announcement that prompted him to describe his method to the Royal Society, and within the year he was able to follow this up with an important refinement. His first exposures had taken half an hour or more, because he had waited for the sensitized paper to darken within the camera. But he then discovered that paper which was removed much earlier already bore an invisible, or latent, image that could subsequently be made to appear by chemical action. Using gallic acid as his accelerator, or 'exciting liquid', he succeeded in reducing exposure times to two or three minutes, and by 1841 he was ready to patent what he named the calotype process.

Whether it is Daguerre or Fox Talbot who should be regarded as the inventor of photography is debatable. Daguerre's announcement was certainly the first, but Fox Talbot could hardly have publicized his method a mere 24 days later had he not been working on it, as he claimed, for some time already. It was the daguerreotype, rather than the calotype, that was photography's first commercial success. But it was the calotype that pointed the eventual way forward, with its use of the negative-positive method and its manipulation of the latent image.

Each process was, of course, startling and each was to be superseded, though not before both had gained from a discovery made public by Sir John Herschel before the eventful year of 1839 was over. Herschel had been aware for some 20 years that sodium thiosulphate, or 'hypo', dissolved silver salts. He applied this knowledge to the problem of arresting the darkening process and fixing the photographic image. Washing the plate, negative or print with hypo, he established, dissolved the light-sensitive chemicals still on the surface and stopped any further reaction to light. An effective fixative had been found, which was to be adopted for both daguerreotypes and calotypes, and which was to become an essential item in the darkroom store cupboard.

## Through a glass brightly

Although Fox Talbot's negatives made possible the multiple reproduction of an image, the paper they were made of, even when rendered translucent by waxing, was not an ideal material for its purpose. Paper is fibrous, and prints made by shining light through paper negatives lacked precise definition. So the 1851 introduction by Frederick Scott Archer of a glass-negative process was a very important step forward.

Archer's wet-collodion process was a marked improvement on both of the pioneering methods, combining the repeatability of the calotype with the sharp image of the daguerreotype. As a result, it quickly became standard professional practice and played its part in promoting a burgeoning of studios in towns all over the world. When travelling in areas where there were no towns, professionals and well-heeled amateurs took their own portable studios with them; and the topographical and documentary possibilities of photography were enthusiastically explored.

Yet Archer's process was both messy and laborious. The glass was coated with collodion, a sticky substance produced by dissolving gun cotton in ether. This served as a base to hold the photosensitive silver nitrate to the plate. Collodion was used in hospitals for dressing wounds, since it quickly dried to form a protective film. Unfortunately, what was convenient for medicine was less so for photography: once the collodion dried, it sealed in the silver nitrate and rendered it inactive. So the glass could not be coated until the last minute, when it was covered with collodion and dipped into silver nitrate. Then it had to be put into the camera, exposed, taken out and treated with pyrogallic acid, to bring out the latent image, all before the collodion had hardened. This meant that the operator had to work quickly. It also meant that a darkroom had to be at hand immediately before and immediately after the picture was taken. For travelling photographers the implications were alarming, but darkroom tents and carts were devised and used to remarkable effect.

Once the glass negative had been created, a print could be made at relative leisure. The glass was placed on top of a piece of sensitized paper, which was then subjected to a dose of light, developed and fixed. This produced a picture in which the dark and light areas were once again distributed as in real life. The complete process called for some skill and dispatch on the part of the practitioner, but the outcome was highly satisfactory. The glass negative produced an image of good quality and also gave the photographer an opportunity to sell more than one copy of the picture. The wet-collodion method was, therefore, a great success. It held sway in the studio for the next 20 years, and the countless surviving portraits dating from the studio boom of the 1860s owe their existence to Frederick Scott Archer (Figures 5 and 6).

The salted paper that Fox Talbot had created for his prints served well enough for use with collodion glass negatives, but it was albumen paper that quickly came to dominate the market. This was introduced in 1850 by Blanquart Everard, and the albumen of chickens' eggs was a key ingredient. Yolks and whites were separated and the whites beaten to a foam with which the paper was eventually coated, before being treated with salt and silver nitrate. The albumen adhered well to the paper and kept the chemicals evenly dispersed. It dried clear and, unlike collodion, it dried without destroying photosensitivity. It served its purpose admirably and, as a result, most Victorian paper prints and almost all of those made

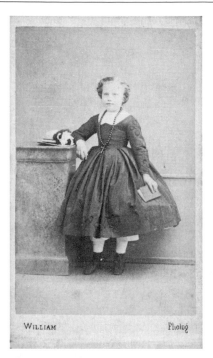

**Figure 5** Carte de visite; William, Dunkerque    **Figure 6** Carte de visite; J. G. Miller, Oxford

between the late 1850s and the late 1880s were on albumen paper. Its manufacture grew into a thriving industry, especially in Germany, which by 1890 supplied four times as much albumen paper to the USA as was domestically produced. Even in 1894, by which time alternative papers were making headway, one Dresden company was processing 6,000 eggs per day.

Recipes varied, with some producers favouring stale eggs, some fermenting the whites, and some opting for two layers of albumen. Fermentation and double-coating both led to a glossier finish on the eventual print. At best, a strong image with well-differentiated dark tones was the outcome, though highlights generally yellowed with the passage of time and some fading of the deeper browns frequently occurred (Figure 7). Often it is the older examples that have best survived the ageing process (Figure 8).

But the wet-collodion method did not always lead to paper prints. Some three years after launching his technique, Frederick Scott Archer, working with Peter Fry, introduced the wet-collodion positive, or ambrotype. This was a way of turning the negative itself into a finished picture. The first step was to make the glass negative in the normal way. A rather thin underexposed negative was most suitable, and its pallor could be increased by chemical bleaching. The effect was of a greyish image on clear glass (Figure 9). This was then given a black backing. Felt was sometimes used,

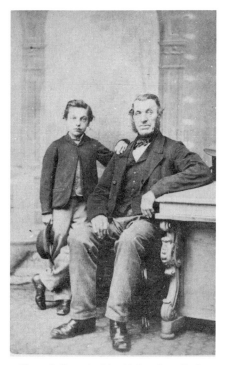

**Figure 7** Carte de visite; H. Bramham, York     **Figure 8** Carte de visite; E. Johnson, Wisbech

but much more usual was a coating of black varnish or shellac. So, as one viewed the piece of glass and looked through the image to the black backing, the formerly transparent areas appeared black, while the greyish areas now appeared pale by contrast (Figure 10). The end product was an apparently positive image on glass (Figure 11), which could then be appropriately framed or cased.

Given the method of their production, it is not surprising that ambrotypes often looked more black-and-grey than black-and-white. They also shared two limitations with the daguerreotype. First, an ambrotype was a one-off image. Secondly, it was reversed, as in a mirror, with the left-hand side of the subject appearing as the right-hand side of the portrait. Thus a wedding ring could appear to be worn on the right hand, and buttons could seem to be done up the wrong way (Figure 12). This reversal could be righted by coating the front of the negative glass, then putting a second piece of glass behind the image for protection, and viewing the package from the other side. In practice, though, reversal seems to have been pretty generally accepted – perhaps because it showed subjects as they were used to seeing themselves in the looking glass and called for no mental readjustment to a slightly unfamiliar image.

Whatever material was used to host the finished picture, glass was now firmly established as the most popular material for photographic plates.

**Figure 9** Ambrotype (collodion negative); photographer unknown

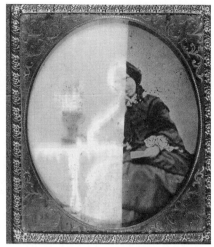

**Figure 10** Ambrotype (partly backed); photographer unknown

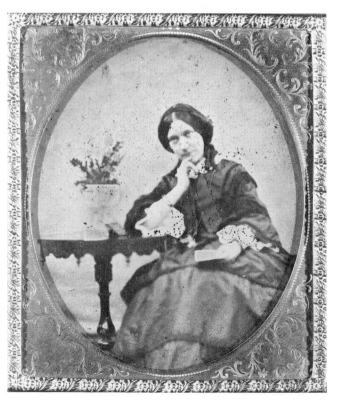

**Figure 11** Ambrotype (finished article); photographer unknown

**Figure 12** Ambrotype;
photographer unknown

But the efficiency of those plates depended on the hardening time of collodion. Some kind of dry-plate process was needed. In fact, though, wet collodion was so firmly established that the earliest dry-plate method, commercially available from 1860, failed to make any significant impact. But when in 1871 Richard Leach Maddox announced a way of using gelatin in the preparation of dry plates, the business of conversion began. His plates were coated with a mixture of cadmium bromide, silver nitrate and gelatin, and they remained sensitive when dry. This meant they could be prepared in advance, and they spared cameras from the damage caused by frequent contact with wet and sticky chemicals. Even then, the change was fairly slow at first. The new plates were on the market from 1873, but they were less economical because, unlike wet-collodion plates, they could not be scraped clean and recycled. Nevertheless, their advantages were undeniable, and in the late 1870s improvements in the preparation procedure led to much greater light-sensitivity and a corresponding reduction of exposure times. It was perhaps this that clinched the argument. At any rate, by the mid 1880s dry plates had become the norm, and they were to continue in use until the First World War and after (Figure 13).

Whereas the collodion plates had to be prepared on the spot, the gelatin plates could be made up in advance and stored. This meant that they could

be manufactured commercially, and the invention by George Eastman, in 1879, of an emulsion-coating machine ushered in an age of mass production. He was, thus, a figure of some importance in the rise of the dry plate, but his main impact on the history of photography was yet to come.

## Photography comes of age

Whilst the story of mainstream photography may appropriately be seen in terms of the progress from wet to dry glass negatives, there were, at the same time, other currents of innovation. Of these, if the river imagery can be pursued, the tintype (Figure 14) might be considered an oxbow lake of some size. This method, introduced by Hamilton Smith in the mid 1850s, used a thin sheet of iron as the photographic plate, and from this is derived the more accurate alternative name of ferrotype. The blackened metal was coated with wet collodion emulsion, and the processing took place inside a specially designed camera. This made it ideal for the travelling

**Figure 13** Modern contact print from original amateur glass negative

**Figure 14** Tintype; photographer unknown

photographer, and the cheapness and speed of the operation went some way to offset the dullness of the image. If the ambrotype tended towards grey and black, the tintype tended towards dark grey and black.

There were also experiments with the camera itself, of which the tintype camera is just one example. Simple pinhole cameras were still used by some purists. The archaeologist Sir Flinders Petrie designed one to photograph the pyramids in the 1880s and persevered with the technique well into the 20th century. Generally, though, cameras grew more complex, benefiting from improved lenses, bellows arrangements, shutters and, in some cases, multiple lenses for taking a number of pictures on one plate.

But the next key event was a shift away from glass negatives to something lighter, less fragile and more flexible. Celluloid had been invented as early as 1860 and was first produced in clear, thin sheets in 1888. The person who recognized its potential was George Eastman.

Since pioneering the dry-plate production line, Eastman had already added to his photographical achievements. In 1885 he had devised a gelatin-coated paper-backed strip which could be used in a roll, and in 1888 he had launched a simple box camera, the Number 1 Kodak, designed to hold this roll. As the strip was wound from one spool to another, it offered a continuous series of photosensitive faces for exposure. The roll film had been born. It was sealed inside the camera and it had room for 100 small circular images. The customer bought the package, took the pictures, and returned the magic box unopened for processing. Hence the famous Kodak slogan 'You press the button – we do the rest'.

Eastman quickly saw the possibilities of celluloid for making roll film. Then he added refinements. Daylight loading reduced the frequency of trips to the darkroom, and a numbered backing enabled exposures to be counted through a small window in the camera. He produced new cameras, too, in both box and folding formats.

But the great landmark event was the appearance in February 1900 of the Box Brownie. This was simply a ready-loaded box, made of wood and card and fitted with a rotary shutter. It was held at waist level and was marked with a V on top to aid aiming. It cost a dollar in the United States or five shillings in Britain, and it brought photography within reach of everyone. Over 100,000 of these cheap, small and easily operated cameras were sold in the first year, half of them on the eastern side of the Atlantic. Now amateurs could take pictures anywhere there was enough light, and then pass the unopened camera over to professionals to handle the chemistry required to develop the negatives and print the positives.

The roll-film revolution effectively set the agenda for the whole of the 20th century. There was, of course, some continued use of plates by professionals and dedicated amateurs, and the century would go on to witness the film pack, the film disc and the advent of digital imaging. But it was essentially the age of the roll film. This would undergo changes over the years, with increasingly sensitive emulsions that could reduce exposure times and with the gradual shift, during the 1930s and 1940s, from highly inflammable nitrocellulose to safety film. New sizes were brought out to fit new cameras. At first, prints were made by placing a negative directly onto a piece of photographic paper, so a film had to give negatives that were big enough to be turned into comfortably viewable prints. From the 1930s, however, the processing trade was increasingly well equipped with efficient enlargers, which projected a magnified image of the negative onto the paper, so smaller films became a practical proposition.

**Figure 15** Roll-film print; amateur photographer

Whilst the first 40 years of the 20th century saw a number of important photographic advances, there was often a gap between introduction and popular adoption. This book is concerned with photographs from Victorian times through to the 1940s – and colour film, 35mm film, the SLR camera, the Polaroid camera and flash photography all appeared in the latter part of this period. Yet none of them came into widespread use until after (in some cases, well after) the Second World War. Family-album pictures deriving from any of these inventions will almost always prove to be from the 1950s or later.

So the point at which this discussion of photography breaks off is one that leaves it hovering on several brinks. A number of new developments had occurred, but they were generally not likely to filter through to the family album until the world had both been to war again and passed through the period of austerity that followed. It is therefore pleasing to come across a flash photograph of the typing pool at Bain's Insurance in 1940 (Figure 15), even though the flash has missed half the group and illuminated the window and door instead. The picture's soldier recipient almost certainly didn't quibble about the lighting. As for ourselves, we can see it as a foretaste of innovations that were to take hold in the second half of the century.

# 3 The Rise of Popular Photography

## Portraits for the people

The working definition of popular photography has to change with the passage of time. When the 19th century is considered, it means 'photography for the people'; in the 20th century, it increasingly comes to mean 'photography by the people'.

In the early years, the practitioners of photography could, broadly, be divided into gentlemen and players. Photography was both expensive and time-consuming, and was therefore an activity for the relatively leisured and moneyed classes. Fox Talbot, as a gentleman photographer, stood at the beginning of what was to become a country-house tradition, in which nobility, squires, academics and professionals recorded each other, their servants, their houses, their estates and their travels. Prince Albert and the Reverend Charles Lutwidge Dodgson, alias Lewis Carroll, were among the best-known of such amateurs. Women, too, took up the new pastime. Julia Margaret Cameron, remembered by a niece for wearing stained clothes and smelling of chemicals, was among the most enthusiastic, and her striking pictures, as well as her fearsome manner, have earned her a place in the photographic pantheon. But she was far from unique, and followed in the footsteps of such practitioners as Lady Clementina Hawarden, Lady Frances Jocelyn and Lady Lucy Bridgeman, all of whom handled the new medium with skill.

There were also those who were alive to the commercial possibilities of the new science. Fox Talbot had given the calotype extensive legal protection and only a few licences were sold, but in France Daguerre's process was made widely and quickly available. The announcement of his method was promptly followed by brisk business for the opticians and chemists' shops of Paris, and within months his instructions had been translated into a dozen languages.

Daguerre had patented his method in England, and it was Richard Beard who bought the right to operate the country's first professional portrait studio, which he opened at Regent Street's Royal Polytechnic Institution on 23 March 1841. It was fitted with a blue-glass skylight that could be revolved to make the most of the daylight upon which the process depended. This meant that, in good weather and in the middle of the day, an adequate exposure could be achieved in under two minutes. Success

was immediate, and more than enough to encourage Antoine Claudet to open the capital's second studio three months later, in a glasshouse on the roof of the Royal Adelaide Gallery.

Beard's investment not only allowed him to make and sell daguerreotypes; it also permitted him to license other practitioners. He didn't lack applicants. At least eight studios (the first of them in Plymouth) opened in the provinces before the year was out, and a further eight were established soon after. Most of these businesses did well enough to survive, but they were quite widely scattered; and from 1843 there was some filling in of geographical gaps. This was achieved partly by the selling of licences for a handful of new areas, and partly by licensees spending some time on the road, taking temporary premises in a new town near their base for a few months before moving on. Broad rather than dense coverage was probably appropriate enough. Daguerreotypes were not cheap, and the earliest studios would have needed a fairly large catchment area to produce enough affluent customers to support the business.

Nevertheless, having a photograph taken was much less expensive than having a picture painted and, although beyond the reach of most people, the daguerreotype opened up the possibility of portraiture to many who would never have previously entertained the notion. At this time the patrons of photographic studios in London were paying a guinea for the privilege of having their likeness made, or two guineas if they wanted it to be hand-coloured. What had been restricted to the titled or landed few was now available to a significant, if still relatively well-off, segment of the population.

If the daguerreotype made portraiture accessible to the professional and political classes, the ambrotype took the popularization of photography a step further, as well as weakening the daguerreotype's hold on the market. Ambrotypes cost less. Both the materials and the process were less expensive, for the silver used in making collodion negatives could eventually be recovered, whereas the silver used for a daguerreotype became part of the finished picture. Ambrotypes could also be more cheaply presented. It was usual to protect the delicate surface of a daguerreotype by putting it behind a thin metal mount and a piece of glass, before fitting it into a frame or case. Ambrotypes tended to receive similar treatment, but economies were possible. If the emulsion side of the negative was viewed through its own glass, no further layer was needed. Brass mounts, or matts, were commonly used to offset daguerreotypes, but for ambrotypes the metal used was often pinchbeck, a cheap gold-coloured alloy produced in thin sheets that could be stamped and cut to size. Finally, ambrotype frames and cases were often made of less expensive materials – for example, leather was often replaced by leathercloth, papier mâché or a mouldable thermoplastic material made from shellac and sawdust. The finished product, although not actually cheap, was certainly less expensive than the daguerreotype. Having a portrait made was still something for the

middle class, but a much broader middle class than before.

The development that would bring portraits within reach of an even wider section of the population was the carte de visite. When this arrived on the scene, it had an enormous impact. The 'carte' was a small photograph, printed on paper from a glass negative and then mounted on a slightly larger piece of card (Figure 16). The standard image size was around 3¼ × 2¼ inches (8.3 × 5.7 cm), with the mount bringing the finished article up to 4 × 2½ inches (10.2 × 6.4 cm).

The name carte de visite suggests a relationship with the calling card, a social lubricant in vogue in the 19th century. Such a card, printed with the owner's name, could be left at a house, in a basket or on a tray provided for the purpose, as a way of giving fair warning that a social call might be expected. Or it could be sent in, by servant, in the hope that it would be sufficiently welcome for its owner to be invited to follow it. It has been suggested that, both in Europe and in the United States, there was some early use of cartes de visite as illustrated calling cards, and a few photographers appear to have tried to promote this possibility. But their success seems to have been very limited, and the carte was destined to have a much wider and less formal use. The visiting card belonged to the world of polite enquiry, etiquette and the negotiation of social relationships, whereas the carte de visite quickly came to stand for a world of warm social contact and for such activities as giving and sharing.

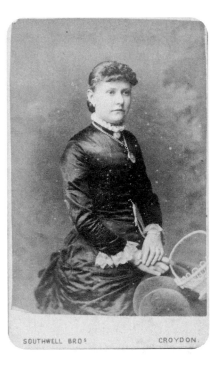

**Figure 16** Carte de visite;
Southwell Brothers, Croydon

Its beginnings, however, were rather tentative. In the early 1850s André Disderi, a Parisian photographer, devised a way of making multiple images on a single photographic plate. What he came up with was a sliding plate holder combined with four lenses. The back of the camera could be moved and the chosen lens uncovered to allow a different portion of the plate to be exposed during each of a series of eight shots. The full set of images would be printed up from the glass negative all at the same time, and then cut up for mounting. The pictures were small, but the savings achieved by processing eight at a time made them relatively cheap. Nevertheless, demand was at first distinctly modest.

Disderi's breakthrough is one of those events that is hard to assign confidently to either history or legend. The story goes that as the French Emperor, Napoleon III, was setting out for Italy at the head of his troops in 1859, he passed Disderi's premises and stopped. Then, leaving a whole army outside, he went into the studio to pose, in full military splendour, for a set of cartes. Napoleon's officers, we are told, promptly decided to follow his example, while the rest of the army waited a little longer.

Few things can be better for business than having a passing emperor pop into your studio. If something is good enough for him, it will be good enough for plenty of other people. So, suddenly, the carte de visite was in demand.

The new format was soon exported. In Britain, as in France, there was a slowish start. The introduction was made in 1857 by Marion & Co., a French photographic supplier and publisher which already had a well-established London base. But popularity had to wait until 1860, when John Mayall was invited to make cartes of Queen Victoria and Prince Albert. The royal couple had been fascinated by photography since the beginning of the 1850s, and darkrooms had already been set up at Buckingham Palace and at Windsor. Now they allowed themselves to be photographed by a 'multiplying camera', and in so doing made Mayall's fortune. Permission was given for the results to be published in book form, but copies were also made available as individual photographs, and these achieved huge sales. They also set an example, for where the Queen showed the way, her subjects followed in droves.

It was probably C. D. Fredericks who, in 1859, introduced the carte de visite to the United States. There, too, the format was given a strong and effective nudge in the direction of popularity. Fittingly, though, for a republic, there was no need of royal or imperial families to give the necessary impetus. That was provided, much more democratically, by war. The American Civil War was to divide families. For them, the carte offered a way of symbolically keeping young men in the bosom of the family, and of keeping the family (often literally) close to the bosom of the young man. The solace of photography was an aspect that quickly became apparent in the USA.

Once the carte de visite became popular, technical refinements followed. Multiplying cameras, as they soon came to be called, were devised with

many variations of moving back and multi-lensed front, so that anything from two to 32 images came to be fitted onto a single glass plate. Practitioners proliferated, too. In 1861 there were 160 portrait photographers in London, and by 1866 the number had risen to over 280. Provincial towns saw a similar growth in studios (Figure 17). In Cambridge, for instance, three studios were listed in Kelly's 1858 Post Office Directory, five were shown in 1864, and eight appeared in 1869. In relative terms, its fenland neighbour, the modest market town and port of Wisbech, saw an even more dramatic boom, with a rise from one studio in 1858 to six in 1869.

The total output was impressive. Just one studio might produce anything between 20,000 and 80,000 cartes per year, so nationally sales could be counted in hundreds of millions. Photography had become available to the people on a staggering scale.

Because Disderi had patented his format, the size of cartes became an international standard. This meant that a universal storage and display system could be introduced – which enabled families scattered across the globe to exchange images in the knowledge that they could be as easily looked after in the far corners of empire as in an English cathedral town. In short, the family album had been born.

It was taken up with enthusiasm. It is said that Queen Victoria amassed more than a hundred albums of cartes, full of carefully identified and dated

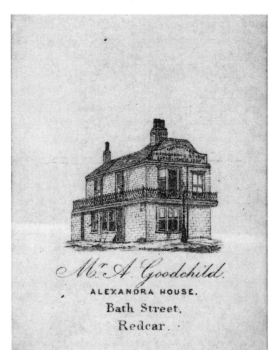

**Figure 17** Carte mount;
A. Goodchild, Redcar

pictures of her own family and other notable figures of the day. Her subjects were not slow to emulate her, and such was the popularity of the carte that a new term, 'cartomania', was coined to do it justice. People collected pictures of themselves and their immediate families. They exchanged portraits with more distant relations and with friends, and added in pictures of their servants and, possibly, their animals. Then they might introduce into the collection a few pictures of celebrities. Royal figures were, of course, great favourites, but room could also be found for local luminaries, with clergymen proving to be in particular demand (Figure 18). Finally, the collection might be topped up with the occasional place of significance to the family, or perhaps with a novelty image or two depicting ethnic costumes, staged tableaux, or endearing children.

The cards were cheap and they were easily circulated. Unlike ambrotypes and daguerreotypes, no glass was needed to support the image or to protect it, so no case or frame was required. They were small and light, so they could easily be consigned to the post. Since cartes came in a set, rather than as a one-off, and since further prints could readily be made from the negative, people could afford to be generous in the distribution of their likenesses. They could give photographs to friends and relations and

DEAN OF LICHFIELD.
MARION & C°                    LONDON.

**Figure 18** Carte de visite; Marion, London

exchange photos with them, and they could, and did, send pictures all over the world. Oliver Wendell Holmes described the carte as 'the social currency of civilization'.

Every craze reaches a peak and then begins to fall off. That proved true even of the carte de visite, though it has to be observed that the decline was relative. By the end of the 1860s the demand had become a little less intense, but cartes were still made and sold in great numbers, and they continued to enjoy a very healthy share of the market until at least the 1890s. Indeed, some studios were still producing photos of carte size in Edwardian and even early Georgian years. Printed on thin card rather than pasted on a mount, these pictures fitted very happily into the pre-formed apertures in treasured family albums. But by the second half of the 1860s there was the opportunity for something new to capture the public imagination.

That something proved to be the cabinet print (Figure 19). Like the carte, it was a paper print made from a glass negative and pasted on a board mount. Like the carte, too, it began life as a product of the wet-plate process and albumen paper but outlived both. The difference related to nothing technical. The cabinet print was, simply, bigger. The picture measured around 4 × 5½ inches (10.2 × 13.9 cm), and the cardboard mount brought the whole thing up to about 4½ × 6½ inches (11.4 × 16.5 cm). In fact, pictures of this size were not unprecedented. Topographical photographers had found them well suited to the presentation of scenic views. What was new was the adoption of the format, from around 1866 onwards, by the studio practitioner.

If it was hoped that the cabinet print would supplant the carte de visite, the wish was long in fulfilment. Cartes had a further 30 years or more of active life ahead of them. It was true, though, that they had reached a peak which could not be sustained for ever. There was room for something different to move in and fill a niche in the market. Cabinet prints were more expensive than cartes, but they were still relatively cheap and in due course they proved a success. This took time, and although it is not especially unusual to find cabinet prints (like Figure 19) that date from the 1870s, examples from the 1880s and 1890s are much more common. Certainly it was well into the 1880s before the cabinet print could be said to outsell the carte, and it never reached the dizzy heights of popularity once scaled by its small relation.

For the last three decades of the century carte and cabinet print coexisted perfectly happily. What is more, they cohabited. A new generation of albums was devised to hold pictures of both sizes. Whereas the precut apertures in carte albums were all of the same dimensions, the mixed-format albums interspersed pages that would accommodate two or four cartes with pages designed to take a single cabinet print. This played its part in the growing attention given to the albums themselves. They were meant for holding treasured family possessions, and they came to have a

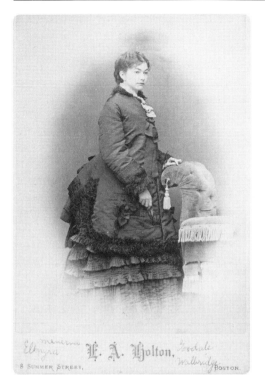

**Figure 19** Cabinet print;
E. A. Holton, Boston, Massachusetts

sumptuousness that was in accord with their importance. Padded bindings, brass clasps and tooled leather covers all contributed to making the family album a striking focus of drawing-room interest. In addition, the pages themselves offered a surface for decoration. Simple carte albums tended to have small pages with little room for graphic flourishes, though illustrated pages are not unknown. The larger productions, however, afforded greater scope and where four-carte pages and cabinet-print pages sat side by side, the pages for the cabinet prints offered quite a lot of marginal space for decoration.

Quality of embellishment varied considerably. Country scenes, birds, butterflies and flowers (especially flowers) were all popular, and sometimes the execution was so indifferent as to defy identification of the species depicted. At best, though, the illustrated pages have a distinct charm, catching the soft tones of leaves and petals or the reflection of sky on water (Figure 20).

Like the carte, the cabinet print survived into the 20th century, and post-Edwardian examples can be found. Together, they were the dominating studio formats that brought portraiture to the Victorian public at large.

This does not mean that other formats were not tried, especially around the turn of the century. Promenade prints, boudoir prints, coupon, panel

**Figure 20**  Cabinet print in album page; Hardingham R. Mehew, Wisbech

and junior cabinet prints (Figure 21) all made their appearance, competing for a share of the market. To list their sizes would be of limited help, partly because few examples turn up in family collections and partly because confusion cannot be wholly avoided. 'Panel print', for instance, was a term used to describe two very different sizes of picture, whilst other photographs (for example, Figures 1 and 22) survive that do not seem to fit into any of the familiar categories. The failure of these varied novelty sizes

**Figure 21** Junior cabinet print;
Walter Gardner, Boston, Massachusetts

**Figure 22** Novelty format;
J. Brokenshire, Penzance

to make a major mark is hardly surprising. The reason for their limited success is also the reason for the staying power of cartes and cabinet prints. People already had maturing portrait collections in albums specifically designed for the two dominant formats. There were sometimes empty spaces to accommodate any photos of suitable shape that might come along. But new shapes could only be slipped in untidily, if at all.

Varying the size and shape of the picture was not the only way of introducing novelty. Different materials were tried out as a photographic base, and pictures appeared on porcelain, enamel and glassware. Of these, the opal print (Figure 23) merits passing notice. Introduced in 1865 and meeting a modest demand until around the end of the century, these pictures were printed on translucent white glass, which gave the finished product an air of delicate distinction.

There remain two kinds of Victorian photograph which – though not comparable to the carte or cabinet print – were highly popular. The first of these found its way into countless homes without catering to the demand for likenesses. The stereoscopic picture put in its first appearance in the days of the daguerreotype and, in the 1850s and early 1860s, became photography's earliest craze, predating even cartomania. In subsequent

**Figure 23** Opal print; photographer unknown

years the taste re-emerged from time to time, sometimes accompanied by
newly designed viewing equipment.

Stereoscopy worked from the starting point that each of our eyes has a
slightly different field of vision. It is the juxtaposition of these two views
that allows us to see in three dimensions. Stereo photos simulated this

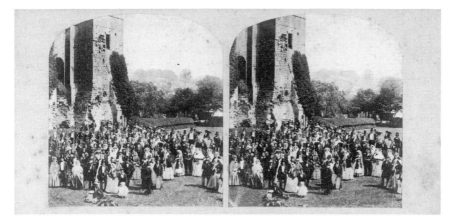

**Figure 24** Stereoscopic photograph; photographer unknown

arrangement of nature by presenting images that were taken by two separate lenses, spaced slightly apart, and placed in a viewer through which each eye could see only one image. The brain was then left to put the two impressions together and reinterpret them in three dimensions.

Although some stereo portraits were made, especially in the daguerreotype period, pictures that exploited depth of image through the representation of buildings, landscapes and staged tableaux were much more common. Figure 24 combines people and a dramatic setting by showing an unidentified gathering at Kenilworth Castle. The images have been carefully coloured by hand and, although the humans are very small, examination with a magnifying glass reveals a gratifying array of crinolines and stovepipe hats.

Whilst the popularity of the stereo picture may have been concentrated among the middle classes, no qualification is needed when referring to the popularity of the tintype. Hamilton Smith's pictures on iron were the cheapest of all to produce, and their in-camera processing made them perfect for the itinerant photographer. Pictures could be taken at fairs and seaside resorts or in hastily set up booths, so the expenses incurred by studio and darkroom were neatly sidestepped. Multi-lensed cameras were able to give over 30 exposures on a single thin metal plate, which could then be cut up into the separate images. Preparation of the plates was often perfunctory, as the wearing away of the emulsion suggests in some surviving examples and as the bubbling of overgenerously coated chemicals indicates in others. Mounting, if attempted, often involved thin, roughly cut pinchbeck; and protective glass was often dispensed with. Cheapest of all were the gem tintypes (Figure 25), which packed the maximum number of exposures onto one plate and which measured no more than 1 × ½ inch (2.5 × 1.3 cm). These tiny pictures could be set in a paper or card mount, which brought them up to a size that would fit into a carte de visite album space.

**Figure 25** Gem tintype;
T. Rodger, Sheffield

The tintype made portraiture available even to those for whom cartes de visite seemed expensive. So, not surprisingly, it ranked low in the photographic social order. That, at any rate, tended to be the case in Europe. In the United States, however, the situation was a little different. There, the tintype achieved a degree of respectability that eluded it on the eastern side of the Atlantic. This difference in attitude may be seen even in the preferred name, for in the USA there was a tendency to favour the more accurate term 'ferrotype' over the rather disparaging 'tintype'. It may be that the American Civil War helped the tintype find acceptance. Whilst not the first war to be noticed by the camera, it was (as already mentioned) the first in which the ordinary soldier could leave images of himself at home with his family and carry photographs of loved ones into battle. Metal was more robust than paper and less brittle than glass, so the tintype met this need in a very satisfactory way.

Figure 26 provides an example of an American tintype. The metal is roughly cut and now a little buckled, and the face is sadly scratched, but

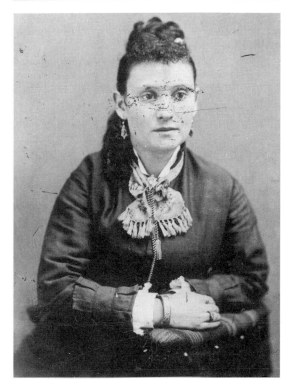

**Figure 26** Tintype;
photographer unknown

the contrasts are quite good and the wistfulness of expression seems unforced. As a finishing touch, the cheeks have been lightly tinted pink. The photograph also serves as a reminder that generalizations are never more than that: although acquired in the USA, it was offered for sale under the label of 'tintype'.

## In the glasshouse

Since the studio boom and the introduction of new processes and formats brought the ownership of a portrait within everybody's reach, it is reasonable to think of our Victorian ancestors queuing up in ever swelling numbers to have their photographs taken. It seems reasonable, too, to wonder just what that experience was like for them. The answer, of course, is not a simple one. The studios that they visited varied from the well appointed (Figure 27) to the distinctly makeshift (Figure 28). They also changed over the decades. Tastes in furnishings developed, electric lighting came into use in most (though not all) premises by the end of the century, and exposure times were counted in seconds rather than minutes. But even though there is insufficient space for a full investigation of the subject, it is worth sampling the studio experience, for a visit to the photographer was a significant event in Victorian life.

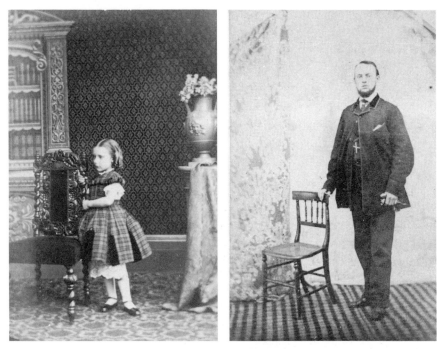

**Figure 27**  Carte de visite; E. Johnson, Wisbech      **Figure 28**  Carte de visite; photographer unknown

The reception rooms of the first London studios were temples of ornamental plasterwork, velvet and gilt, with changing rooms, maids in attendance and cosmeticians at the ready. Suitable clothes were provided, though customer resistance soon led, instead, to the issuing of advice on which of the sitter's own clothes should be chosen. Attention to colour and texture was necessary, since the early photographic emulsions were not capable of a faithful interpretation of the full spectrum. Large expanses of white or black appeared as solid masses unmarked by detail. (Photographers sometimes tried to moderate the shining starkness of a white shirt front by draping across it a piece of black cloth, which they then whisked off part way through the exposure.) Blue seemed unnaturally pale, and green and red looked black. Patterned fabrics and materials with some degree of sheen, to reflect highlights, were approved of. Features might need to be toned down by make-up, in order to avoid a Stygian cast to cheeks and lips.

The studio itself, often ominously referred to as 'the operating room', was frequently on an upper floor, or even on the roof, since it was necessary to make the most of whatever light was available. This made its way in through wall and ceiling which were often fitted with blue glass. This was chosen for its ability to reduce glare without increasing the time needed for exposures. Reflected light could be added to the total illumination by the careful placing of mirrors. In the centre of the room a

revolving chair was set, ready to be turned to catch the best of the light.

Here the client sat and submitted to the support of the headrest or neck clamp, a device already employed by painters to keep their subjects still. It was not a piece of equipment for which the public felt much love, though help was certainly needed when maintaining immobility for up to three minutes. 'The chair does look formidable with that headrest fixed to its back', observed Edmund Saul Dixon in *Household Words*, 'and might be taken for a milder mode of garrotting criminals.' Nevertheless, and despite improvements in exposure times, such aids continued in use as late as the 1870s.

Imagine, then, what it was like to visit a studio for the first time. It is the 1860s, and sitting for a carte de visite is the latest fad. Everybody else is trying it, and you have decided to do so, too. You have dressed yourself in your Sunday best and, as far as you are able, have selected your clothes in accordance with the printed recommendations about colours and fabrics given to you when you made your appointment. But best clothes are not always the most comfortable, and your unease is added to by a slight anxiety that your wardrobe did not run to absolute compliance with the instructions. You now wait in a reception room of a grandeur and plushness that are far from homely, reflecting on stories told of their ordeals by friends and relations, and wondering how you will control the desire to blink or sneeze.

The photographer arrives, possibly with hands and clothing stained by chemicals, and perhaps a little pale and wheezing, as habitual inhalation of the fumes often took its toll on the practitioner's health. You are led up a flight or more of stairs and into the sanctum, where another surprise greets you. You have maintained your outward composure at the sight of the opulent waiting room and the possibly seedy photographer, but now you find yourself in a room suffused with eerie bluish light.

You allow yourself to be placed in a chair, in front of a curtained wall or painted scene. The neck clamp is applied to keep your head still (Figure 29). Then you are given directions for the arrangement of your limbs so that they are all more or less the same distance from the camera (Figure 30) – for early lenses could handle only limited depth of focus, and it helped to have all important components of the picture in much the same plane. The photographic artist disappears beneath the dark cloth draped over the camera, takes in the upside down view that is presented, and perhaps suggests an adjustment or two to the pose.

From this point on, you have to stay still, while the photographer attends to the procedures necessary to the wet-plate process. If you are lucky, the studio employs an assistant or two, who will have been in the darkroom, applying the wet collodion mixture to the glass while the principal was arranging the pose. The coated plate is brought out in a light-excluding plate holder or dark slide, the photographer takes a final glance through the lens, covers it over, removes the focusing screen, slips

the encased plate into the camera, pulls aside the mask of the plate holder so that light can get to the glass within, and then removes the camera's lens cover.

Until this moment, you have been merely playing at keeping still. Now you have to do so in earnest. A quick blink may perhaps not matter too much, but a series of blinks will certainly give the eyes a clouded look thanks to a faint image of eyelid being superimposed on pupil and iris. The exposure length could vary considerably according to time of year, state of weather and time of day. In the early days of photography, tales of sitters falling asleep had been matched by anecdotes of photographers slipping out for refreshment and forgetting all about their clients. By the 1860s, however, three or four seconds may be all that is needed in summer, or a quarter of a minute in winter. But even a mere four seconds is some thousand times longer than will be routinely required of your descendants at the beginning of the 21st century.

You will, then, be relieved when the photographer replaces the lens cover, closes the front of the dark slide, and removes it for darkroom treatment. You will understand how Edmund Dixon felt, when he compared sitting for a portrait to having a tooth drawn.

Unfortunately no early studio has survived, though some mock-ups have been attempted. A leap of half a century is therefore necessary before we can find an authentic studio that can still be visited. The oldest known studio in England is the second of the premises used by William Hayes,

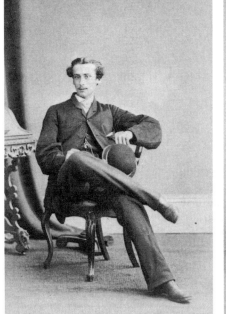
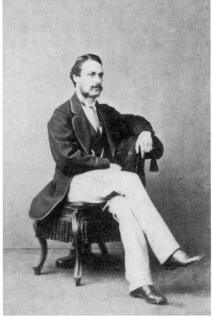

**Figure 29** Carte de visite; Cobb, Ipswich          **Figure 30** Carte de visite; Kyles, Portobello

opened in 1911 and now re-erected at the Ryedale Folk Museum at Hutton-le-Hole in Yorkshire.

It is a modest single-storey building. A very small vestibule leads into the studio proper, at the end of which a chair awaits the client. Brackets have been fixed high on the wall behind the chair, and from these can be hung a backcloth or painted scene. The wall facing the sitter as well as the wall to the right and half of the sloping ceiling are all made of glass, for Hayes still favoured the use of natural light to create his pictures, despite electricity having been introduced into some studios in the late 1870s. (In fact, it was not until the 1920s that he purchased an electric enlarger, preferring until then to make contact prints by sunlight out of doors, finishing several hundred pictures on a bright day but perhaps as few as 70 during the short and gloomy hours of winter light.) The extensive wall and ceiling windows are of interest, as they are composed of clean photographic glass plates and represent an effective and cost-saving exercise in recycling. The furniture, which is fairly simple, includes a cane table, an Art Nouveau chair in the Mackintosh style, painted white, and a selection of plant pots. Beyond the studio can be found a darkroom, an ordinary workroom without blackout, and a storeroom for materials.

The overall effect is of simplicity. The studio is unpretentious and dates from a time when being photographed had become a routine part of life. It would have taken a very timid customer to feel overawed by these surroundings. But then, William Hayes was the kind of competent local operator who had long since ceased to be a novelty. Indeed, he belonged to a generation of studio photographers that was facing serious competition from a public now able to take many of its own pictures.

But before that competition is considered, it is worth pausing for a brief look back at the studio practitioners who during the 60 years or so of Queen Victoria's reign had made a portrait something that anybody could possess.

The early professionals came to photography from a wide range of backgrounds. Artists, pharmacists, watchmakers and optical technicians figured prominently in their number, each bringing to the task skills that would prove useful to an activity which was both art and science. Owners of fancy goods emporia, used to dealing in novelty, were perhaps understandable converts to the trade, though the usefully qualifying skills of Cleer Alger, an insurance agent, Thomas Grimwood, a draper and hatter, and Thomas Howard, a gasworks owner, are less obvious.

Some of these professionals were women, and their numbers grew during the Victorian period. Although by the end of the century over a quarter of photographic workers were female, it is easy to be misled, as this figure includes many workers employed solely for processing. Nevertheless, there were women who ran their own businesses, and they were in evidence from the earliest period. In the eastern counties, for instance, by 1846 Mrs C. Adams had her own premises in Lowestoft, Miss

E. Lingard was active in Cambridge, Miss H. Smith practised in Great Yarmouth, and Mrs J. Stannard was busy in Norwich. Common, too, were women who played a prominent part in the operation of a family concern then, after being widowed, carried on a husband's work in their own name. There is evidence that women were valued in the studio (Figure 31) – not least for their social skills in putting sitters at their ease – and the involvement of wives and daughters in a family business could make a telling difference to its success.

This sense of a family at work is particularly strong in the case of the McLeans of North Walsham in Norfolk. George gave his name to the business throughout the 1870s, after which it was run for a number of years by Mrs Jane McLean. Then in the mid 1890s the Misses Blanche and Mildred presided for a while, before Lawrence headed operations through the Edwardian years.

Of course, as in any boom, photographers came and went. Some reverted after a short time to their earlier trades. Others enjoyed long and profitable careers, working alone or with partners, moving to more prestigious addresses, and sometimes building up small chains of studios. John Richard Sawyer of Norwich provides a good example of a

**Figure 31** Carte mount;
Jessamine Studio, Wandsworth

professional whose rise ran parallel to that of popular studio photography.

Sawyer was an active member of the Norwich Photographic Society, founded in 1854, and may already have opened his first studio by then. In 1859 he was principal of Sawyer & Co., at 42 London Street. By the mid 1860s, he had dropped the '& Co.' but was still at the same address. A directory entry from this time indicates a secondary (perhaps original) trade as cutler.

Business prospered, and surviving studio work shows that Sawyer invested in a range of good-quality furniture, props and backcloths. He kept up with the trends, for a carte from the late 1860s shows an early example of a studio stile. Customers kept on coming, and by 1868 he is said to have accumulated an archive of some 25,000 wet-collodion negatives. Although becoming increasingly assured in his art, he took care to acknowledge the natural forces that lay behind it. Many of his photographic mounts from this period bore the tag 'Sol fecit' ('The sun made it'); sometimes, however, he opted more ambitiously for 'Solem certissima signa sequuntur' ('Extremely faithful images result from the action of the sun').

He continued at London Street through the decade and expanded into number 46, which operated for a time under the name 'Sawyer's Italian Studios'. The building was three storeys high, with a balustrade around the top, which suggests that the roof level was turned to good use, perhaps for

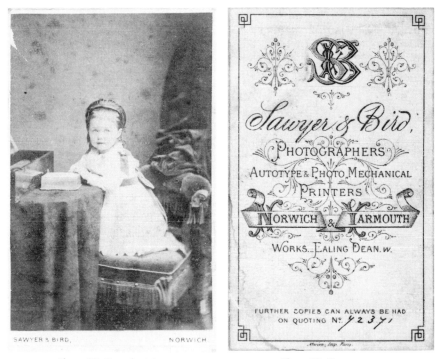

**Figure 32** Carte de visite;
Sawyer & Bird, Norwich

**Figure 33** Carte mount;
Sawyer & Bird, Norwich

making prints. Round arched windows on the first and second floors illuminated spacious rooms behind them. The ground floor provided a shop front, including a large window for displaying samples of the proprietor's work. For a while, too, towards the end of the 1860s, Sawyer ran a business at 18 Brook Street, Ipswich.

The early 1870s saw the formation of a partnership, Sawyer & Bird (Figure 32), along with the opening of new studios at 32 London Street and at 182 King Street, Great Yarmouth. Operations at Norwich and Yarmouth kept going for a further dozen years or so, making their latest trade directory appearance in 1883. But that was not the end of Sawyer & Bird. As well as doing steady business in Norfolk, the partners had been active elsewhere. London premises were taken at much the same time as the two men joined forces, and addresses in Rathbone Place, Regent Street West and Oxford Street all made an appearance in the corporate curriculum vitae. At one point the firm was briefly expanded to become Sawyer, Bird & Foxlee. Studio work was a part of the pair's London activities, but they were also involved in the development of the autotype process, a form of carbon printing used for the reproduction of photographs on the printed page (Figure 33). So when Messrs Sawyer and

**Figure 34** Carte de visite;
Clément Malfait, Dunkerque

**Figure 35** Carte de visite; C. M. Tullberg, Malmö

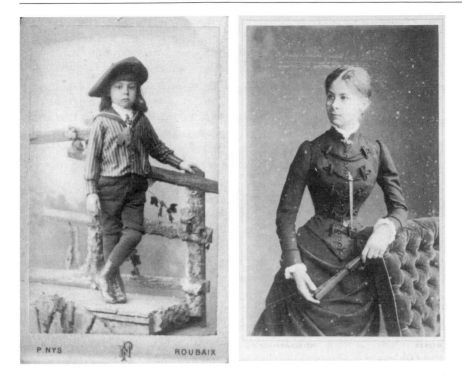

**Figure 36** Carte de visite; P. Nys, Roubaix

**Figure 37** Carte de visite;
J. C. Schaarwächter, Berlin

Bird retired from the East Anglian scene in the first half of the 1880s, it was in order to concentrate on their now established career in London as directors of the Autotype Company.

Sawyer has led us from the provinces to the capital, but it is worth taking our journey a stage further and considering studio photography in an international context. Some photographers, following the early example of Antoine Claudet, moved from country to country. Innovators from different nations contributed towards the development of processes. Ideas and fashions were quick to spread, and the visual language of the professional studio took on a universal quality.

So it is that the furnishings seen in a French (Figure 34) or Swedish (Figure 35) studio of the 1860s are much the same as those employed by British photographers of the time. So it is, too, that the pose encouraged and camera position adopted by the Swedish practitioner, or by an American photographer in the 1870s (Figure 26), look wholly familiar. Occasionally one is aware that the clothes are different, so that Figure 36 looks distinctly French. Often, however, there seems nothing characteristically ethnic about costume (as witness Figures 19, 34 and 37). In one sense, at least, the much trumpeted global village is nothing new.

## Do-it-yourself

Nothing lasts for ever, and with the turn of the century the professional photographer faced a major challenge. The studio was to survive and make a healthy living for some time yet, but popular photography was to pass into the hands of the amateur.

It was, of course, the introduction of roll film and, more particularly, the launch of the Box Brownie that brought about the revolution. Eastman's marketing of the first transparent roll film in 1889 paved the way for a generation of amateur photographers, as well as making possible the development of Thomas Edison's motion-picture camera two years later. His first daylight-loading camera in 1891 enabled the photographer to put in a new film without retreating to the darkroom. His Folding Pocket Kodak Camera of 1898 introduced a 2¼ × 3¼ inch (5.7 × 8.3 cm) negative, which was to become a standard size for decades. But it was the first Brownie camera that turned photography into a hobby within financial reach of just about everyone.

Roll film was not the only means of producing a series of shots without constant recourse to the darkroom. In 1898, for instance, the Bullard Folding Magazine Camera was being promoted as 'entirely too fine' for the $10 that it cost. It took 18 small glass plates at a single loading and, the makers assured the public, the magazine worked 'with the speed and accuracy of a repeating rifle'. Refinements were added, and the company boasted that 'our enlarged and superb line for 1901 will be incomparable'. Nevertheless, by the next year Bullard had faltered and had been taken over by the Seneca Camera Company.

Glass plates did survive, but they became the equipment of the professional and the serious amateur. In time, they were replaced by single-sheet celluloid film. For the public at large, however, roll film offered convenience, while new cameras and improved film materials and processing only served to strengthen what had quickly become an unshakable hold on the market. The Brownie had made the initial breakthrough, and despite imitations by competitors the impetus was not lost. 'Plant the Brownie acorn,' George Eastman reputedly said to one of his executives in the early 1900s, 'and the Kodak oak will grow.' In 1905 a Kodak advertisement picked up this idea, showing an oak tree with roots which grew from cartridges of roll film encased in acorns. As the century advanced, a succession of new branches pushed out from the trunk.

First and foremost, 1912 saw the appearance of the Vest Pocket Kodak, which quickly became the most popular camera of its day. When closed, it really was small and flat enough to be slipped into a pocket, and this accounted for much of its success, as it was keenly taken up by troops during the First World War. Whilst serving soldiers were not supposed to carry cameras, what the sergeant's eye didn't see, the sergeant's heart didn't grieve over. The first full year of the war saw a huge surge in sales,

and by the time the camera was discontinued in the 1920s more than 2 million had been sold.

A novelty introduced in 1914 was the Kodak Autographic feature. This was a hinged flap in the back of the camera that opened to reveal a small area of the film's backing paper. A metal stylus was provided, with which the photographer could write the date or identifying details in the uncovered space. Pressure from the stylus caused a tissue between film and paper to become transparent, allowing light to pass through to the film. It was like writing on the film itself, and the outcome was a set of negatives with labels built into the narrow spaces beween frames. This refinement was exclusive to Kodak, and it was incorporated into most of the company's folding cameras from 1914 until the early 1930s.

New materials were tried in order to make cameras cheaper and lighter. Bakelite made its first appearance in 1928, the Rajar Number 6 folding camera being the first fully plastic model to reach the market. On this occasion Eastman's company found itself following someone else's initiative, for its own bakelite Number 2 Hawkette did not appear until 1930.

Box and folding cameras continued to flourish side by side until well after the Second World War. Broadly speaking, the folding camera, with its extending bellows, was the likely choice of the slightly more serious amateur, while the less complicated box camera was the favourite of Everyman.

It was also the favourite of Everywoman. In the Edwardian and early

**Figure 38** The Kodak Girl
(PRO, COPY 1/553)

Georgian years photography became a widespread hobby, and a high proportion of those wielding a camera were female. In 1905 a Birmingham newspaper concluded that the pastime had become as much one for women as it was for men, and Kodak dealers in the 1920s reported that women formed the majority of snapshot-camera owners.

Eastman's company was well aware of this female market and made a point of targeting it. Advertisements for Kodak cameras habitually showed women as the users, and 1910 saw the launch of the first poster to feature the soon to be familiar Kodak Girl. This young woman – drawn by various artists over the years, though most famously by Fred Pegram – carried her Kodak with her to coast and countryside for some 40 years before being pensioned off. It may be tempting to suspect something a little patronizing about the approach. After all, the company that was busy courting the female user was also claiming that its cameras 'are so simple that they can be easily operated by any school boy or girl'. Did the adverts carry a subtext suggesting that even mere women could make the products work? Perhaps Kodak should be given the benefit of the doubt, since the Kodak Girl was as likely to be seen holding a folding camera as its simpler box relation (Figure 38).

Questions might also be asked about coloured cameras. The late 1920s saw the production of the Number 2 Portrait Brownie in six colour finishes, as well as the standard black. The idea was to tie in with the latest

**Figure 39** Roll-film print; amateur photographer     **Figure 40** Roll-film print; amateur photographer

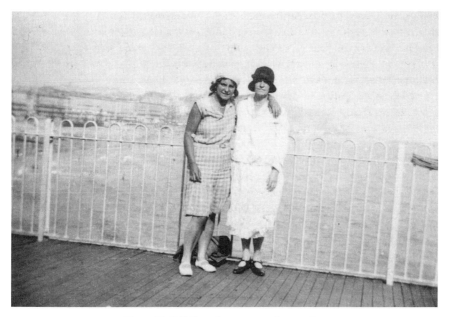

**Figure 41**  Roll-film print; amateur photographer

fashions, and the cameras were specifically aimed at women. The Vanity Kodak followed, in a choice of five colours and with a silk lined case to match. In 1930 the Beau Brownie, available in four colours, incorporated a front plate of Art Deco design. Other manufacturers followed suit, and the concept of camera as fashion accessory reached its height with the marketing of matching camera, lipstick and face-powder sets. If this amounted to treating women photographers as vain triflers with the art, it had only limited success: in a few years the makers had reverted to the customary black.

Whatever the sex of the individual camera user, popular photography had changed dramatically. In abandoning the plate camera in favour of the film camera, it had passed from professional to amateur hands, and this had a major impact on the nature of the photos themselves.

The typical photograph was a snapshot, rather than a studio production. It was taken in the open air, because that is where adequate light was to be found. Nevertheless, it was not always happily lit. Users had learnt that they must not point the camera directly at the sun, so they tended to keep the light source behind them (Figure 39). This meant that the subject's face was illuminated, but it could also lead to features being shaded by hat brims, or to eyes squinting against the sun. In addition, figures were often placed further from the camera than was really necessary. This was perhaps partly because the lenses of simple cameras could not be focused down for close-ups, but it was also the natural result of an anxiety to fit in the whole subject. It was only too easy to cut off vital body parts by relying too trustingly on an unsophisticated viewfinder.

However, the distance between camera and subject could have a useful side effect for family historians, showing an individual in an environment which often included the back garden (Figure 40) or the home.

There is, therefore, a kind of snapshot balance sheet. The loss with amateur pictures is often due to their amateurishness. There may be poor focus, cluttered backgrounds or a failure to hold the camera straight (Figure 41). (It must be stressed, though, that many amateurs quickly became very competent, and that by the 1920s and 1930s increasing numbers could afford to do their own processing.) The gain is a new immediacy and informality – sometimes rather self-conscious, but often relaxed and unaffected (Figure 39).

The professional practitioner, however, had not disappeared and was still making a contribution to popular photography in the traditional studio way. There was, too, a new item in the professional's repertoire – the postcard (Figure 42). In fact, the sending of pictorial cards through the post came late to Britain. The practice had begun in the United States during the 1870s, where non-picture cards had been permitted postal traffic since 1867. But once the British authorities allowed this form of communication in 1894, it rapidly grew in popularity. It was quick, cheap and convenient, and a speedy postal service meant that messages could even arrive on the day they were sent. By the end of the century, people were making extensive use of postcards. They sent them to confirm their safe

**Figure 42** Postcard; photographer unknown

arrival, to describe the holiday accommodation, food and weather, and to warn of their impending return. They also sent them for the sake of the pictures they bore, to remind the recipient of a loved place, to recall shared interests and experiences, or to arouse the sentimental response triggered by animals or children. Sometimes they sent cards to be added to a collection, for postcard albums quickly became inheritors of both the Victorian scrapbook tradition and the taste for collecting novelty pictures which cartes and cabinet prints had partly fed. Naturally enough, publishers responded to demand, and postcards bearing both painted and photographic images appeared in increasing numbers. Every imaginable subject was depicted, sometimes in collectable series, and the cards came to be seen as desirable items in their own right, whether or not they passed through the post.

It therefore comes as no surprise to discover that studio photographers hit on the postcard as an ideal format. Many of them took and published local scenes and events, and found a ready market for their work. But they also saw the possibilities of the postcard for portraits. A standard (though not obligatory) size of 5½ × 3½ inches (13.9 × 8.8 cm) had been established in 1899, collections were growing, and albums were being designed to hold them. Previous attempts to supplant the carte and cabinet print may have failed, but they had no context to fit into. The postcard portrait was a new application for a format that was already becoming established. If people wanted to exchange photos, as they always had, these new productions could be sent through the post. But they could exist quite independently, too. Figure 42 has the headings 'Correspondence' and 'Address' printed on the plain side, but it has never been posted. Instead, the subject has written across both spaces: 'To Dear Mr & Mrs West. Wishing you a Very Happy Xmas & a Bright New Year. With love from Aggie.'

Postcard-format photos were a continuing success. Professionals still produced pictures in other (mainly fairly large) sizes, but the postcard served them well for decades. Modern collectors of postcards view the period from 1900 to 1918 as a golden age. Certainly it was the period of heaviest postal use, and in the year ending March 1904 more than 7 million cards were received in Britain. The period between the two World Wars saw increased delivery charges and some falling away from the previous peak. But portrait postcards retained a degree of popularity. This was doubtless due in part to the fact that, whatever was printed on the back, their subjects rarely had any intention of putting them in a letter box.

Despite the roll-film revolution, professionals therefore still had a part to play in the history of popular photography. It was, though, a part that increasingly had to do with such family milestones as new babies, 21st birthdays, engagements and the like. A visit to the studio now seemed relatively expensive, compared to the cost of the boxful of pictures offered by an amateur's camera. So it became, as it had been in earlier days, something of an occasion, and the products of a visit, logically enough, took on a certain desirability. They could be worth saving for.

*Littlehampton*
1933.

Sunny Snaps

**Figure 43** Postcard;
Sunny Snaps, Littlehampton

Cooperative savings schemes were a common feature of working-class life in the first half of the 20th century, and one way to afford a studio portrait was to get together with other people from work or the pub. 'I used to belong to a Photograph Club at the factory,' Daisy Thomas told Eve Hostettler, compiler of a collection of East End photographs entitled *Island Women*. 'You'd pay a penny a week, and when your turn came up, you'd go and have your photograph done. I had that taken at Whiffin's, in East India Dock Road.' She dated the portrait in question to around 1916.

One late bastion of professional photography in the world of popular images was the seaside picture. Day trips and even extended holidays were coming within the reach of more people, and a souvenir of the occasion was very agreeable. The promenade photographer could offer postcard or tintype pictures reasonably cheaply, and holidaymakers might be in the mood to cheerfully accept the expenditure. As a result, family collections often include shots taken on the prom or pier. If the inheritor is lucky, they may even carry the date as part of the design (Figure 43).

The fact remains, however, that the amateur had gained ground that was not to be lost. In the 19th century popular photography had essentially been something that happened in a studio. In contrast, the 20th century was the age of the private individual, liberated and empowered by roll film to record images in a possibly artless but certainly personal way.

# 4 Dating and Interpreting Photographs

## Looking at the artefact

In studying a photograph and deciding what it tells us of our ancestors' world, it makes some sense to start with the picture as an object, taking into account such physical properties as dimensions, materials and surface finish, and noting how it is presented. This will help us to recognize the kind of photograph we are dealing with, which in turn will often provide the first step towards dating, even though that will not usually be a giant step.

Daguerreotypes and ambrotypes that have survived are likely to come down to us in a case or frame, as they needed that protection in order to survive. Tintypes, too, are often framed in one way or another, less from necessity than from a desire to ape their betters. A tintype on its own, or simply mounted on card or paper, is simple enough to identify: it is made of a thin sheet of metal. When framed under glass, it may give momentary pause for thought, for its tendency to greyness is shared by the ambrotype. Nevertheless, making decisions about cased images is usually fairly easy.

The daguerreotype (Figure 4), dating from the 1840s or 1850s, is essentially a negative. It has to be turned at the correct angle to the light for the positive image to appear, floating like a hologram in silver space. It is so highly reflective that you can see your face in it or bounce light off it. The way in which age has affected it can be telling: because the image is very delicate, it may have acquired a network of fine scratches. The daguerreotype is, therefore, quite distinctive, though that does not prevent non-specialist dealers from sometimes mistakenly offering ambrotypes as daguerreotypes.

The ambrotype, although also essentially a negative, has been treated so that the positive image dominates. (Sometimes, but by no means always, it is possible by turning the picture this way and that to catch the light in such a way as to suddenly rediscover the negative image.) Its highlights are often muted and greyish. As with daguerreotypes, the way in which it has aged may prove diagnostic, for the black shellac backing becomes brittle and crazes or flakes, leaving areas of clear glass showing (Figure 44). Ambrotypes generally date from the third quarter of the 19th century.

The lightness of a tintype can be disguised by its packaging. If it is behind glass, it can feel and look very much like an ambrotype, though the

**Figure 44** Ambrotype; photographer unknown

poor contrast and dull highlights are often even more pronounced. It is more likely to be in a frame than a case, and when this is turned over the metal back of the picture is sometimes revealed. If there is any doubt, a small magnet can be useful, as it will attract the iron of a tintype but have no effect on the copper of a daguerreotype or the glass of an ambrotype. Although the iron is thin and buckles easily, a small magnet (such as a fridge magnet) should do it no harm. Tintypes had a long life, appearing in the second half of the 1850s and still being made by the occasional seaside photographer around the time of the Second World War.

As for the cases and frames in which these three kinds of photograph may be found, the cheaper they look the less likely they are to house daguerreotypes and the more likely to hold tintypes. If the case is made of solid moulded plastic, it most probably contains an ambrotype – as thermoplastic, which found its first commercial use in the presentation of photographs, came late for daguerreotypes and was rather grand for tintypes. Finally, it should be noted that such generalizations can be undermined by the possibility that the photograph may have been remounted in a later case or frame.

When it comes to prints that have been made, and often mounted, on card or paper, size is the first consideration, and the three main formats are easily recognized.

Cartes de visite, including card mount, measure about 4½ × 2 inches (10.2 × 6.4 cm), and although examples from the late 1850s are possible, in practice they are unlikely to date from before the early 1860s. Whilst early 20th-century examples are not common, they are sometimes encountered.

Cabinet prints, mounted, measure approximately 4½ × 6½ inches (11.4 × 16.5 cm). Some were produced in the latter part of the 1860s, but

most prove to be from the 1870s or later. Like cartes, they survived into the new century (indeed, Edwardian cabinet prints are not especially rare). With both cartes and cabinet prints, some slight deviation from the stated measurements is not unusual, as small fractions of an inch were not generally critical when it came to slipping pictures into album pages.

A little more variation in size is possible with postcards, for although measurements of 5½ x 3½ inches (13.9 × 8.9 cm) were approved in 1899 and remained the most common ones, they were by no means universally adopted. The introduction in 1926 of minimum and maximum sizes allowed such latitude (nearly 2 inches or 5 cm on length, and over 1¼ inches or 3.2 cm on width) as to provide no significant help with dating. Whilst postcards from the late 1890s may be found, it is more realistic to expect examples to be Edwardian or later.

Prints deriving from roll film present a much more complicated situation. An earliest possible date can be given for many sizes of finished picture. Pictures that were 2¼ inches (5.7 cm) square, for instance, arrived in 1900 with the first Brownies. But matters were not always clear cut, and some introductions turn out to be reintroductions. Thus the new Kodak 616 and 620 films, launched in 1932, produced pictures of the same sizes as those taken by the 1A Folding Pocket Kodak of 1899 and the Number 2 Brownie of 1901 respectively. Then there were cameras that used existing film but fitted two shots into the film space previously used for one. The growing use of enlargers in processing also clouded the issue, for by the 1920s and 1930s there was no reason to assume that the size of a print was the same as, or even proportionately related to, the size of the negative.

It may also be possible to identify photographic processes, though this is not always as easy as some authorities seem to suggest. One person's warm brown may be much the same as another's dark brown or a third's sepia, and toning treatments during printing could result in greater perceived richness of hue. Descriptions of colour, both in these pages and elsewhere, should therefore be regarded as approximate.

Albumen paper was most commonly used for both cartes and cabinet prints, and it was still being chosen by some photographers in the 1890s. It may be recognized by its cream or even yellow highlights and by the middling browns of its darker tones. The contrast may be perfectly effective, but it is not generally dramatic; and there will be some surface sheen, though how strong this is will depend on the recipe chosen during manufacture. However, some early cartes, pursuing a tradition that derived from Fox Talbot, used salted paper – so a carte from the 1860s with a distinctly matt surface could be a salted-paper print dating from the first few years of the decade.

When albumen paper was superseded, carbon printing became the most widely used of its successors (Figure 45). This process, introduced in 1864, was highly resistant to fading. It was used with increasing frequency from the 1880s onward and survived into the 1930s. Its contrasts are

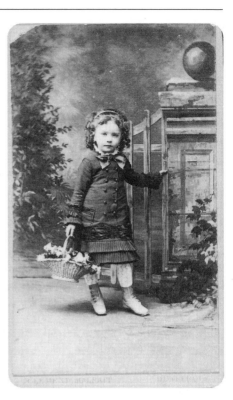

**Figure 45**  Carte de visite;
Clément Malfait, Dunkerque

strong, with white highlights and, usually, black or dense brown shadows, though green, blue and red each enjoyed some brief and limited favour as the base colour. There is sometimes a distinct relief effect where dark and light areas meet. Further help with identification is sometimes given by the mounts: if they bear the words 'permanent' or 'Autotype' (see page 40), then the images they bear are likely to be carbon prints. The process was particularly useful for printing on materials other than paper, and opal prints (Figure 23) are often examples of this practice.

The platinum print, too, is found from time to time amongst family pictures (Figure 21). This process was introduced in 1873 but became rare after 1914, when the high cost of platinum made it too expensive for widespread use. This is rather a pity, since there is an attractive delicacy to a range of tones that stretches from pale silvery highlights, through subtly differentiated greys, to black. Platinum prints are not inclined to fade, but sometimes residual specks of metal in the emulsion cause rust-coloured stains to blemish the surface.

With Victorian and, often, Edwardian paper prints, the mount was an important part of the package, and one that can have its own story to tell. The textual messages of the mounts will be considered in the last section of this chapter, but attention also needs to be given to their design.

Professional photographers soon realized that the card on which a

photograph was pasted represented an opportunity for self-promotion. At the very least, it ought to carry the practitioner's name. Suppliers were also quick to recognize the possibilities offered by mounts, and they encouraged studio proprietors by producing a constantly changing range of card stock. Thus, over the Victorian decades, mounts became stouter and more elaborate, and new designs were available whenever the photographer was ready to order fresh supplies. In a busy studio, with a principal who was alert to the advantages of marketing, new orders might be placed about every six months. Basic designs could be customized by the addition of the operator's details, and it is not uncommon to find a style being used by more than one studio. So, for example, the black-on-yellow illustration of an 18th-century squire by an easel, favoured at one stage by J. N. Paton of Glasgow (Figure 46), was also chosen, in a gold on maroon colour scheme, by Harris & Son of Merthyr and Cardiff. Since tastes in design changed over the years, the style of mount can be a very useful aid to dating.

Carte mounts of the early 1860s were notable for their simplicity (Figure 47). Thin, white and sharp-cornered, they often bore no more than the photographer's name and address – perhaps presented, within the shape of a wreath or shield, as a trade plate. By the 1870s, thicker card was being used, the corners were commonly rounded off, and the information

**Figure 46** Carte mount; J. N. Paton, Glasgow

**Figure 47** Carte mount; J. Nott, Cheltenham          **Figure 48** Carte mount; E. Denney, Exeter

often expanded to fill the whole of the card's surface (Figure 48). Decorative motifs, often of a geometrical kind, began to be introduced and several different fonts might be used for the text. By this time cabinet prints were also an established part of the scene, and what can be said of the mount designs for cartes is generally applicable to them, too. In the 1880s the trend towards greater elaboration continued (Figures 49 and 50). The growing taste for coloured card and coloured inks is exemplified by W. Spilsbury's mount, which uses maroon printing on a pink base. There was often a free-flowing quality and a flourish to the decoration, and the pictorial element became more marked. The preference for stout card with rounded corners continued, though some 1880s designers flirted again, briefly, with the idea of square-cut mounts for cartes (Figure 49).

By the 1890s, or in some cases by the end of the 1880s, the sense of exuberant artistry had reached its height, and angels, cherubs and statuesque young women jostled with images from art and nature for a place on the backs of mounts. The liking for colours, too, expressed itself in its most dramatic way, with much use of dark card and white or gold printing. Figure 51 shows a gold-on-black carte mount, but deep red and bottle green also enjoyed great popularity. Sometimes, though, the problems of making designs stand out against a dark background were

**Figure 49** Carte mount; W. Spilsbury, Hanley    **Figure 50** Carte mount; F. C. Burnham, Brixton

sidestepped and the coloured back was left blank, leaving just the bottom edge of the front of the mount to carry the necessary trade information.

If fashion is thought of in terms of a series of reactions against what has gone before, then the next trend in mount design would have been easy to predict. Many mounts of the later 1890s and most of the ones used during the first years of the new century showed a return to relative simplicity – though not to the simplicity of the 1860s, the aim being dignified understatement rather than naïvety. So what found favour was matt-finish card in pale colours: cream, pearly grey, fawn and buff. Printing in grey, brown, silver or gold meant reduced contrast and a rather more subtle assault on the eye. But it was still possible to suggest richness, and this could be achieved by attention to texture. Pressed-in borders, hatching and stippling gave variety to the surface, and incised lettering added an air of quiet distinction. Decoration of the back of the mount became a rarity.

This change in taste came at the point when the carte and cabinet print were losing their hold over the market. Where mounted prints, rather than postcards, succeeded them, the tendency was for the framing surround to become wider. Photographs from the Edwardian years are often set against a much larger expanse of white or pale space than had been customary, and this allowed plenty of room for the newly popular texturing tech-

**Figure 51** Carte mount;
Charles E. Weale, King's Lynn

niques to be developed. It also meant that mounts had to be cut down, if pictures were to fill the remaining spaces in long-established family albums.

Although the Edwardian period does not represent the end of the mount's history, it is the point at which the mount loses importance and becomes much less informative. More robust photographic papers and the rise of the postcard and snapshot diminished its importance. The pasting of image to card was largely dropped; and the move, insofar as there was one, was towards slip-in cards or backings. Typical of the studio products of the 1930s and 1940s was the fold-over card with slots in the back half, ready to receive the corners of a photograph. But as an object of interest and charm, the mount was a thing of the past.

## Studying the studio

If photographs changed in various ways over the years, so too did the studios in which they were made. Some understanding of studio fashions and practice can therefore help bring alive our pictures from the past, as well as provide help with dating them.

It was as an accompaniment to the carte de visite boom that studio furnishings and settings began to develop. The rise of the professional photographer meant that the studio had become a market to be catered

for. Photographers sought to give weight and moment to their productions, just as portrait painters had done before them; and like the painters, they found that the surroundings could add to the dignity and consequence of the sitter. So, in pictures dating from the 1860s we see the scene-setting ambitions of the studio photographer starting to grow.

The simplest, and sometimes the earliest, settings amount to no more than a plain background in front of which the customer stands or sits (Figure 20). But the Spartan feeling of such an arrangement was often relieved by a plinth (Figure 5) or a heavy curtain (Figure 35). A table might be added, for sitting or standing by, and a cloth might be thrown over it. But as the decade wore on, more impressive contexts were devised. To the plinth, with its feeling of classical solidity, could be added a column or an archway. Anything suggesting an antique and vaguely Greek or Roman world could, after all, only add patrician dignity to the person it accompanied. Then there were the possibilities of the painted backcloth. Even a simple table, chair and curtain, when set in front of a suitable picture, could become something akin to a stage set.

At first, interior scenes were favoured and the effect could be quite modest. In Figure 52, for instance, only part of the blank space has been taken up by the representation of a bookcase. The result is an air of scholarly gravity that wall and curtain alone could never convey. The painting is not wholly convincing and the bookcase stops at the top of the skirting board, but the Victorians seem to have been quite at ease in exercising some willing suspension of disbelief.

By the end of the decade, there was a decided taste for hinting at what lay outside. So an interior scene often included an arch, a window or an arcade, beyond which a glimpse could be caught of a wider and wilder world (Figures 6 and 53). It does not follow, of course, that a photograph taken in front of an open-window backcloth must be later than one set against a bookcase or blank wall. Over the years a well-equipped studio built up a repertoire of settings, with backcloths which could be rolled up and down according to the sitter's or photographer's choice. Given the human tendency to be swayed by novelty, it is not surprising that subjects posing before obviously old-fashioned backcloths are not very often encountered. But the neutral background, with no pictorial backdrop in evidence at all, remained a useful option alongside the ever changing tastes in scene painting.

The lack of a painted context does not, however, mean that a picture cannot be dated from the studio setting. The 1870s, for instance, can often be recognized by furniture. The carved, solid, but not particularly sumptuous chairs of the 1860s gave way to much plusher chairs and lecterns. These were thickly padded and richly upholstered, and often adorned by fringing and tassels (Figures 19 and 54).

The 1870s did, however, see a new development in the evolution of the backcloth. Instead of offering mere glimpses through windows, the scene

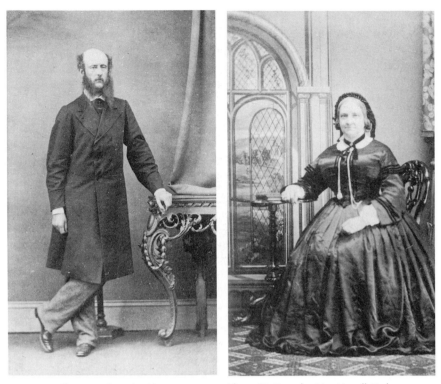

**Figure 52** Carte de visite;           **Figure 53** Carte de visite; Newell, York
W. McLiesh, Darlington

moved, in the imagination, out of doors. Rustic settings became popular, and people posed leaning on gates, fences and stiles in front of painted foliage. There was often, though, a certain starkness about the carpentry involved. Fences might be very clean-cut and regular, like the trellis in Figure 8. When rougher wood was used, there still tended to be a look of newness about the structure, as with the fence and stile in Figure 55. Other outdoor settings were also tried, and the decade saw the first in a long line of seaside scenes.

The 1880s brought a change that had more to do with style than content. Nature, woodwork and architecture all still made their appearance, but they were treated with a kind of rugged romanticism. Balustrades, popular in the 1860s, became so again, but they were likely to be more weathered or mossy than their predecessors, which had tended to look as if they were fresh from the stonemason's chisel. Fences and stiles had a rougher appearance, with more evidence of grain and less of plane, and with a higher incidence of aged bark and ivy cladding (Figure 56). In short, texture had become important, and branches, artificial rocks and clumps of grass might add a tactile, three-dimensional quality to the foreground. The use of real plants had always been a possibility, but now

**Figure 54** Carte de visite;
M. Tayleure & Son, Pocklington

they were used more regularly and more liberally. A degree of romanticism was often evident in backcloths, too, with expanses of dramatically lit sky seen between treetops, or with Gothic ruins perched on craggy outcrops. Vaguely leafy backgrounds became moonlit glades, and beaches were rocky and tide-lashed.

These trends continued into the 1890s, and were added to by a taste for the exotic. Oriental screens, first seen in the previous decade, became more popular; and novelty items such as mirrors, bamboo furniture (Figure 1) and white furs for babies made more frequent appearances. The greenery that was imported into the studio often included hothouse potted plants and palms. Indeed, the suggestion occasionally seemed to be less of leafy dell than of steamy jungle. Although it was still quite possible for the join between outdoor backcloth and indoor floor to be clearly seen, there was an increased likelihood of that line being camouflaged, with simulated nature appearing underfoot as well as behind (Figure 57). But even when verisimilitude was attempted, it had its limits. Figure 58, dating from 1901, links horizontal and vertical planes very credibly, but the grass runs out in the foreground and the frame supporting the backcloth is visible, revealing a selection of scenes waiting to be chosen and unwound. The resources of this photographer, William Amey of Portsmouth, were clearly quite extensive.

**Figure 55** Carte de visite;
Frederick Brown, Walsall

**Figure 56** Carte de visite; P. Nys, Roubaix

But a richly imagined setting is not the most characteristic feature of photographs from the turn of the century. A strong taste for close-up portraits (which will be investigated in the next section of this chapter) meant that props and furniture frequently disappeared from the frame, and that backdrops were often seen only in part, if at all.

Trends in studio setting can be harder to discern in the Edwardian and early Georgian years. This is partly because the studio no longer dominated image making in the way it once had. It is perhaps also partly because the close-ups of the 1890s had made the subject's physical context seem less important. Certainly the use of backcloths continued, but they were far from obligatory. Some studios might attempt realistic settings, but others continued the traditions of sylvan romance and noble architecture, without shrinking from the Victorian incongruity of introducing a table or chair into an open-air scene (Figure 42).

Between the two world wars examples of roughly datable settings may still be found, although they are hardly the norm. The whimsicality of the backdrop chosen by W. Curtis at his Ark Studio in Blackpool perhaps suggests something of the style of children's book illustration in the 1920s or 1930s, though it is crudely executed, and it is debatable whether Noah is being tossed by waves or foundering on rocks (Figure 59). Jerome's

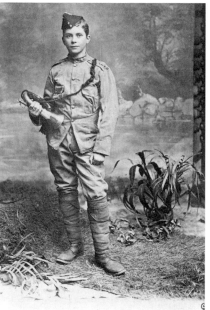

**Figure 57** Cabinet print;
G. W. Wilson & Co., Aberdeen

**Figure 58** Unmounted print; William Amey,
Portsmouth (PRO, COPY 1/445)

studio in Croydon (Figure 60) comes as something of a sober contrast, with the formality of its Art Deco setting. Had '1933' not already been written on the photograph, its approximate age could have been estimated from the knowledge that this decorative style was popular from the late 1920s until well into the 1930s.

Whilst the studio setting can help us towards dating a picture, it would be a pity if we did not also enjoy it in its own right, for there are often details worth noticing.

There is, for instance, the matter of realism. The mixture of furniture and fresh air seen in Figure 42 was by no means unusual in 19th-century and early 20th-century pictures. Nor was the undisguised interface between floor and backdrop that is evident in Figure 6. Our forebears seem to have found no great difficulty in ignoring such impediments to belief. But then it is no more than a matter of convention, and in its arts and entertainments each age chooses which improbable conventions to accept. Less typical, because more realistic, is Figure 45, which presents an interesting problem in deciding where two dimensions become three. The bottom of the backcloth can be clearly seen to our left. The masonry to the right seems rather further forward, and yet judging by the stone ball it is still painted. The fence is attached to the stonework, but the girl's hand is holding one of its uprights, and part of that hand disappears behind the

**Figure 59** Postcard; W. Curtis, Blackpool          **Figure 60** Postcard; Jerome, Croydon

wood. Where exactly, then, does free-standing set take over from flat canvas?

It is worth observing, too, that some settings were designed specifically for children. This is often true of seaside scenes, particularly those of the rockpool variety, where subjects might choose to brandish their own shrimp-nets, buckets and spades or could make use of studio equipment thoughtfully provided for the occasion. Sets including swings were also provided with the younger customer predominantly in mind (Figure 61). Maritime sets – which tied in very well with the long-lived fashion for dressing the young in sailor suits – had much in common with beach sets, but were more likely to feature boats, lifebelts and coils of rope. In the 1880s and 1890s, masthead sets enjoyed something of a vogue, providing spars and rigging for the young tar to clamber on. The maritime set shown in Figure 62 is a fairly modest example of its kind, but it has been chosen for its address, since F. S. Harrison's Wallington studio in Surrey was 40 miles or so from the sea. It was not only coastal studios that offered the opportunity for juvenile seafaring fantasies.

In pictures dating from the 1860s, and even the 1870s, sitter-support is an issue. For women, the period when steadying devices were used coincided with the wearing of wide skirts, which provided ample acreage for concealment. It is not usual, therefore, to be able to pick out the tell-

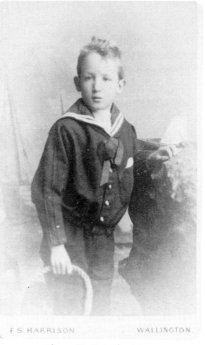

**Figure 61** Carte de visite; E. H. Lee, Anerley

**Figure 62** Carte de visite;
F. S. Harrison, Wallington

tale feet of headrests or neck clamps in female portraits. It is fair to assume, though, that behind most crinolines is hidden a piece of studio equipment (Figures 3 and 53). Men's clothes offered no such help. The upright part of a rest was thin enough to be hidden by legs, but the base was often left peeping out. Evidence of such aids to stillness is not unusual in 1860s photographs of men (Figure 52). The standard way of trying to disguise the base was to pull the bottom of the studio curtain across it, so a hanging descending at an angle is a feature to look out for. This makes Figure 29 rather unusual. The curtain spreads across the floor, showing itself to be quite sufficient for the purposes of concealment. But it has been arranged behind, rather than in front of, the base of the headrest.

When, as sometimes occurs in a family collection, two or more pictures survive from the same time and studio, it can be interesting to look for differences in the setting (Figures 8 and 27). Many photographers were able to offer a choice of backgrounds and furnishings, and it was also often possible to make small alterations within a chosen set. A plinth, for instance, might be made up of stackable units, more or fewer of which could be used according to the height of the person who was about to lean elegantly beside it. Figures 36 and 56 show the same piece of rustic fence, but the accompanying platform has been placed in front of it for the boy and behind it for the girl. Rather different poses are the result. For a taller

subject, of course, the platform could be dispensed with. Notice, too, the slightly differing arrangements of ivy.

Props also deserve a little attention. At the simplest level, they provided subjects with occupation for their hands. Even the back of a chair could serve this purpose (Figure 28), but hats, gloves, canes and umbrellas were useful, too. Books were invaluable, for they could give the hands something to do, whilst adding an air of scholarly seriousness. A book could be held, or placed on a table and left to speak for itself. It could even be used to add a little height to a plinth that was not quite comfortable for leaning on (Figure 34).

As the example of books demonstrates, studio props could be used to say something about the subject. A learned volume might emphasize gravitas, while a lady's fan spoke of elegance (Figure 37). The choice of props was, predictably, often based on notions of what was appropriate to the respective sexes and nowhere was this more apparent than in the toys held by children. Of course, children might bring a favourite toy with them to the studio; but if they didn't, something could always be found for them to hold. Either sex might be given beach equipment or a book, though girls were probably a little more likely to be presented in a studious light than boys (Figure 5). The broad gender assumptions, though, were that boys were active and had toys that they could do something with, while girls were sedentary and held accessories. Thus, boys were shown with boats

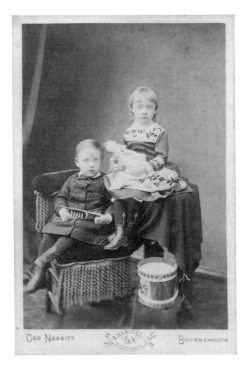

**Figure 63** Cabinet print;
George Nesbitt, Bournemouth

(Figure 62), popguns, mechanical novelties and musical instruments of a martial kind (Figure 63). At the top of the list for girls were dolls (Figure 63) and, above all, posies or baskets of flowers (Figure 45). In this respect the child foreshadowed the woman, for flowers remained a favoured female prop well into young adulthood.

## The photographer's angle

Consideration of a portrait from the photographer's point of view can provide further food for thought. It can even be of some general help with dating.

With Victorian pictures, roughly speaking, the closer the camera is to the sitter, the later the picture is. In the 1860s the common practice was to choose full-length shots so that, whether the subject was sitting or standing, the feet or the bottom of a full-length dress could be seen (Figures 64 and 53). In the case of seated figures, the full-length study is particularly characteristic of the 1860s. For standing subjects, it should be regarded as no more than a tendency, since full-length standing figures were not unknown in later photographs, especially when there was more than one person to be fitted into the frame. As the decade progressed, it became increasingly common to use a chair-back, plinth or balustrade as a rest for the hand or arm of the standing subject.

In the 1870s and 1880s the distance between camera and subject tended to decrease. People were often shown in three-quarter-length or half-length poses (Figure 54); and seated poses became less common, though the chairs did not disappear. They, or lectern-like rests, proved useful for leaning on.

In the 1890s the close-up became enormously popular. Head-and-shoulders, or even head-and-collar, portraits became the standard currency of the studio, and this closeness was underlined by a taste for the vignette, an oval image fading into whiteness at the edges (Figure 65). The result was an image of a head, and often very little else, surrounded by blankness. If the background was pale, the isolation of the face could be dramatic. This concentrated attention on hair, features and elaborate collars, to all of which the improved camera lenses of the 1890s were well able to do justice. The cost, for the family historian, is the loss of other costume detail and of studio furnishings and backcloths. It should be noted that the vignette was not an invention of the 1890s. Earlier examples of the technique can be found, not all of which involve a close-up image (Figure 19). But it was so hugely popular that the vast majority of vignettes can be assigned to the last Victorian decade.

From the beginning of the 20th century, the position of the camera ceases to offer a short cut to dating. The vignette did not entirely disappear, but it was no longer ubiquitous. Full-length studio shots became more common as the postcard rose to the position of dominant format.

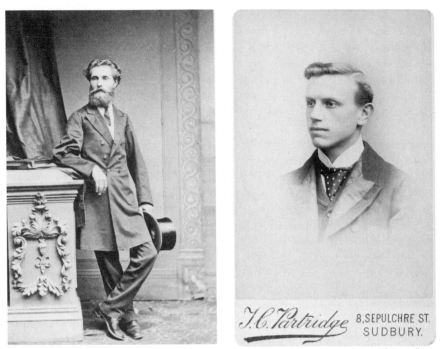

**Figure 64** Carte de visite; W G. Lewis, Bath     **Figure 65** Carte de visite; T. C. Partridge, Sudbury

Broadly speaking, the studio camera was more likely to be further from the subject in the years before the First World War than in the years after it, though that is scarcely a helpful generalization. In the case of snapshot photographs, if feet were hard to see, it was more likely to be because they were distant than because they were out of frame.

But seeing photographs from the photographer's angle involves more than judging distances. The studio operator had the task of posing the client in a way that would be found agreeable, and especially in the earlier days of photography that was not always easy. A pose had to be held for some time, during which, according to Ralph Waldo Emerson, 'hands became clenched as for fight or despair, . . . the brows contracted into a Tartarean frown, and the eyes fixed as they are fixed in a fit, in madness, or in death'. It is therefore easy to believe the tale of an English lady at a French daguerreotype studio who, having sat tensely through the operation, burst into tears as soon as it was over and threw herself into her husband's arms. Of course, exposure times became, on average, shorter, but they still depended on the unpredictable strength of daylight coming through the windows. That remained the case at least until the advent of electricity in the late 1870s, and most practitioners were slow to adopt new ways. Add to exposure length the constraints of wearing Sunday best and, perhaps, of being subjected to the unpopular neck clamp, and the much proclaimed stiffness of Victorian portraits is hardly surprising. Subjects

were often solemn (Figures 16 and 52), sometimes stern (Figure 2), and occasionally grim (Figure 7).

In fact, some modification of the traditional view of Victorian photographs is needed. They are sometimes surprisingly unstrained. Admittedly, the crossed legs of the saturnine gentleman in Figure 52 do little to introduce an air of relaxation. But the subject of Figure 30 seems moderately comfortable and the young man in Figure 29 seems distinctly at ease, despite the use in each case of steadying equipment. As for the 1860s exquisite shown in Figure 64, he may be self-conscious but his coolness would be hard to beat in any age.

Nevertheless, a general tone of unsmiling sobriety in old photographs has to be admitted. But that was not necessarily seen as a drawback. If the limitations of photography dictated poses that could be held with relative ease, the results conveniently coincided with public taste. The Victorians were not seeking to project themselves as grinning lightweights. They wanted to present themselves to the world as full of the qualities that society valued, and the photographer colluded with them to that end.

When taking pictures of men, the task was to create an image of authority, self-reliance and substance. Imposing backcloths and good-quality furniture could help, by surrounding the subject with images of property and solidity. But the man himself had to project desirable qualities, too. Whether the subject was to be seated, firm and immovable, or standing, upright and statuesque, the pose needed a sense of dignity and assurance. So the man in Figure 66 stares steadily ahead, with feet set firmly on the ground but ready at a moment's notice to stride purposefully off. The hands, one on his hat and the other halfway in his pocket, are placed so as to push the elbows out and add to the sense of physical power. Remove the studio setting and place him on a podium, and he could be about to address a public meeting. Place him on a plinth and he would look well as a monument to manly virtue in any public park or square. In Figure 64, despite the air of relaxation, the key message is of elegance and social class; there is no questioning that the subject has presence and is someone who matters.

In women, the qualities most valued were maidenly or matronly demureness and stillness. Stillness, of course, was precisely what early photography could handle best. The dignified and substantial studio settings were still appropriate, for they encouraged a serious view of the sitter, and plants or flowers could always be used to soften the effect. In such surroundings, the young woman of Figure 67 is shown to suitable advantage. There is something self-contained about the pose, perhaps resulting from the fact that her upper body is enfolded by her arms. Her head is turned to give a full view of her face, but her eyes modestly avoid meeting the camera's gaze. Not only are they directed away to her right, but it is not at all clear that they are actually focusing on anything. The resulting faraway look sets her apart from worldly concerns and helps to

**Figure 66** Carte de visite; R. Cade, Ipswich          **Figure 67** Carte de visite; J. Perkins, Bath

idealize her. She has charms, but they are of the quiet kind. The thoughtful stance, leaning gently on an item of furniture with chin or cheek resting on hand, is a favourite in the Victorian lexicon of poses. It was a very useful position to assume, since it could provide a steadying influence for both elbow and head, and it spoke of the calmness and pensiveness that were prized as feminine virtues.

Another favoured female pose came into great use in the 1870s. It involved a rather more wholehearted leaning, with the woman putting some weight on a lectern or chair-back, and with her body angled forward as a result (Figure 54). The sloping line of her body was in accord with the sloping line of 1870s costume (of which more in the next section of this chapter). In terms of body language, she appeared to be rather more approachable and confiding. This effect was strengthened by the fact that the subject was often closer to the camera than would have been the case in the 1860s. Nevertheless, thoughtful expressions and the frequent use of hand-to-face poses ensured that dignity and reserve were not wholly abandoned.

So the positioning of men and women and the poses chosen for them were no mere matter of chance. There were messages to be conveyed, and a good professional operator knew how to convey them. Similar conventions might well be applied to portraits of children, who were often arranged before the camera simply as miniature adults (Figure 56). But the

19th-century photographer faced additional problems when it came to posing the young. They were smaller, which affected their relationship with the studio setting, and they were more liable to fidget. They might also be more nervous. So whilst the ideal of children as docile and tractable was conveniently in line with what photography could capture, there were practical difficulties in persuading them to present those qualities to the camera.

The problem of size could be overcome by adding height. A child could be placed on a platform (Figures 36 and 56), or even stood on a chair or table if necessary. But it was less easy to discourage movement, and a spoilt negative meant more work, especially in the wet-plate era. It is not surprising that some operators tried to avoid photographing children and that others raised their prices when dealing with them. 'Babies', complained an article in *The British Journal of Photography* in 1867, 'are worse than boils!'.

There were, however, those who were more tolerant. Henry Peach Robinson, who became eminent as a photographic artist as well as practising as a studio professional, liked children's unaffected responses to the camera: 'Children cannot act; they must be natural or nothing.' Some photographers sought to reassure parents that their offspring were welcome (Figure 31), and J. Cruickshank Taylor of Newgate Street, London, had 'No extra charge for children' printed on his mounts.

Ways had to be found of supporting the very young, headrests and neck clamps being out of the question for their first few years. Often a baby would be held by the mother or an older sibling. Alternatively, it could be propped on a chair and bolstered up by cushions or furs, then quickly photographed before it had time to fall over. A photograph of the infant Prince Arthur, dating from 1853, shows him standing on what seems to be a table, with a blurred adult hand in mid-air to his left poised ready to catch him – presumably, having let go at the last possible moment before the exposure.

With rather more regard to safety, an infant could be tied in place with a sash or supported by a pair of hands, the rest of whose owner was out of shot. If what look like totally disembodied hands are visible in a portrait of a fur-swathed baby, that is a sign that slits have been cut so that a parent could slip behind the chair and, otherwise invisible, reach through to hold the child.

There remained the problem, both with infants and with slightly older children, of catching their attention and keeping it for as long as the exposure required. Toys and novelties were the common solution. E. T. Whitney, of Rochester, New York, fitted his camera with a toy bird which sang and presented itself intermittently to view. Edward Reeves, of Lewes, used a chime of six bells to intrigue his young sitters and also balanced a model of a high-wire walker on his camera. William Gill, of Colchester, kept an assortment of musical toys, along with a cuckoo clock and a jack-in-the-box, ready to distract small children.

**Figure 68** Carte de visite; Wilkinson,
Sheffield and Birmingham

The various devices seem generally to have worked well enough, and children in photographs often appear intent on whatever is being produced for their entertainment. But if all else failed, there was always bribery to fall back on. Written on the border of Figure 68, opposite what looks like a screwed-up piece of paper, is 'x over'. All is explained on the back of the mount, where we find 'x pkt of sweets. had been sheding a tear a minute or two before'.

In the 20th century, the conventions of posing changed dramatically. The advent of roll film meant that usually the photographer was now a member of the family or a friend, which might be one reason why smiling started to appear in photographs. Faster films and shorter exposure times, of course, provided another reason. Facial expressions no longer had to be premeditated and held, and natural reactions could be caught on film. Society, too, was changing: there was less concern with projecting Victorian values and less objection to informality. The man in Figure 69, photographed at Great Yarmouth in August 1928, had not donned his Sunday best and made a pilgrimage to the studio. He had dressed in holiday clothes and made a quick trip to the newsagent. He looks quite happy, and he may well be so. (Scepticism is probably unnecessary, but we should be aware that photography in the 20th century was as obsessed with happiness as Victorian photography was concerned with dignity.)

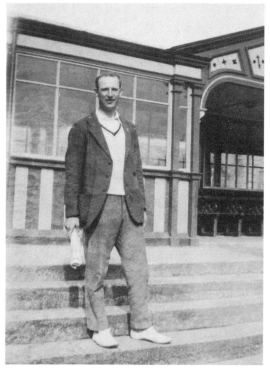

**Figure 69** Roll-film print; amateur photographer

Even in the studio, poses were changing. In the 1920s and 1930s, fashion photographers were exerting an influence and Hollywood was increasingly shaping people's feelings about how they wanted to appear. There were choices, of course. Women who chose not to aspire to the waiflike wistfulness of Lilian Gish could emulate the heavy-lidded inscrutability of Greta Garbo, the defiant brooding of Bette Davis, or the self-contained assurance of Marlene Dietrich. Indeed, fashion-conscious women could adopt all four looks, in that order, between the early 1920s and the late 1930s.

Figure 70, dating from 1924, shows features characteristic of its time. The subject is sitting at an angle to the camera, with her head turned in order to look into the lens. This had become a popular pose, and the photographer has added to its interest by controlling the lighting to dramatic effect, drawing attention to the hair and allowing strong shadow on one side of her face. The backcloth may hint at the past, but the young woman belongs to a new age.

One other aspect of the photographer's point of view is worth a passing mention. Despite all the attention given to lighting, posing and length of exposure, at times the results still left something to be desired. Occasionally, though, there was a chance to put matters right. In such instances, we note how the photographer, dissatisfied with the image, has

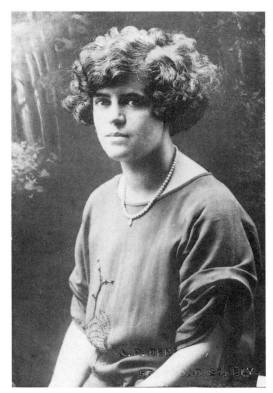

**Figure 70** Postcard;
A. R. Denston, Ely

doctored the print, or more usually the negative, in order to bring about the desired improvement. Sometimes retouching was used in the service of flattery, and sometimes to counter the technical limitations of photographic processes. Now and then, the two motives coincided, when practitioners touched out minor spots or blemishes which were in danger of appearing worse than in real life, because early emulsions made red tones appear unnaturally dark. Figure 34 is an instance where the photographer decided to make up for technical deficiencies. The subject's white shirt and white tie have proved too much for the light-sensitive surface to handle with any gradation of tone. The snowy bow has disappeared against its equally snowy background. Seeing this, the photographer has drawn the tie on the negative, presumably by scratching lines on the darkened surface in order to let light through during printing. The success of this contrivance I leave the reader to judge.

## The message of clothes

Clothes, hairstyles and accessories can be of great help in dating old photographs. Perhaps predictably, women's styles offer more clues than men's, because they changed more frequently. This does not mean that

men cared nothing for their appearance. Rather, the messages they wished their appearance to convey had more to do with stability and reliability than with novelty and transience. For practical purposes, the 1860s provide a convenient starting point. Although photography does go further back, the majority of family photographs do not.

Women, during the first half of the 1860s, were still wearing the crinolines that had already been in vogue for some years. Voluminous skirts, supported by a firm framework of baleen or watch-spring hoops, contrasted with a close-fitting bodice (Figure 53). Until the middle of the decade, sleeves tended to be wide and set low into the shoulder, giving a rather sloping line. An alternative shoulder feature, which gained ground during the 1860s, was the use of braid trimming or epaulettes. Geometrical patterns were popular on sleeves, skirts and shoulders, and the Greek-key design was often used on cuffs or hems. Hairstyles were generally simple, often with central partings and tresses caught back (Figure 3). A useful detail for dating is the visibility of ears, which tended to be covered by the drawn-back hair in the earlier part of the decade but left fully or partly exposed in its middle and later years.

Towards the end of the 1860s, the crinoline cages had fallen out of favour, and it is not uncommon to find pictures of women wearing skirts made to accommodate an infrastructure that was no longer in use. The 1870s found a way of using that redundant fabric to striking effect in the bustle, whereby a full skirt, unsupported by engineering, was caught up behind and supplemented by padding (Figure 19). The bunched-up swathes of material fell away in a sloping line at the back and helped to create the rather forward-tilted stance that was typical of these years. Small hats tipped forward on the brow and the taste for leaning poses both added to the effect.

But what, above all, identifies the 1870s is the profusion of decoration and detail. Brighter dyes had been developed, and this encouraged the combination of varied colours and fabrics in one outfit. Monochrome photographs may not tell us what the colours were, but they can still convey something of the kaleidoscopic results. To this basic exuberance was added ornament upon ornament. Frills, fringing, ribbons, buttons and bows were all part of the dressmaker's armoury, and they were used unsparingly (Figure 55). Scarves, necklaces, brooches, collars and jabots were among the ways of emphasizing the neckline; and there was no need for a woman to decide which she preferred, when she could wear several at the same time (Figure 54). The head, too, was treated to the taste for elaboration, with artificial hair often added to the natural product to achieve ornate or massy creations (Figure 71). There was, however, some reversion to simpler styles in the later years of the decade, and some enthusiastic adoption of the fringe in imitation of Princess Alexandra.

The 1880s brought to women's costume a touch of sobriety – which was inevitable, given fashion's tendency to react. The Princess line, with a long

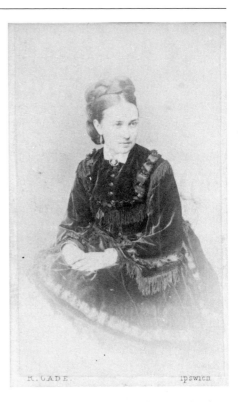

**Figure 71** Carte de visite; R. Cade, Ipswich

tight waist cut to a point in front, was popular, especially during the first half of the decade, while its second half saw the arrival of the tailored suit, worn with a blouse, which was to become increasingly popular in the last years of the century. Corsetry, narrow sleeves and tight bodices buttoned to the throat added to an air of relative severity, though the formality of a small stand-up collar might be alleviated by a white piecrust frill (Figure 16). Women who were at ease with the styles of the 1880s had a smart, often rather military, air (Figure 37), while the less fortunate sometimes looked as if they were growing out of their clothes. Hair was usually arranged simply, often tightly pulled back to emphasize the contours of the head. Fringes, which were still very much in vogue, frequently had a crimped and wispy look.

But severity did not wholly carry the day, for bustles and hats both made assertive statements. Having disappeared from view towards the end of the previous decade, the bustle re-emerged in a new form during the first half of the 1880s. This time it was worn higher, sticking out from the small of the back before falling to the ground (Figure 72). As for hats, they inherited the vigorous imagination that had produced the ornamentation of the 1870s. Ribbons and frills were not enough, and nature was ransacked for trimmings. Fur and feathers were the obvious possibilities, but whole small creatures, stuffed, were also called into use.

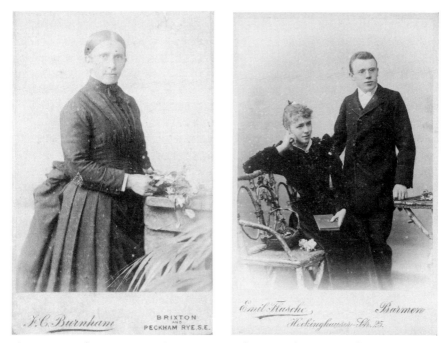

**Figure 72** Carte de visite; F. C. Burnham, Brixton     **Figure 73** Cabinet print; Emil Flasche, Barmen

The 1890s brought a change of emphasis in women's clothing. In the past, crinolines and two incarnations of bustle had drawn the eye to the skirt, but now that settled into relative plainness, with attention being focused more on arms and shoulders. Tight corsets and high necklines with small frills continued to hold sway, but it was sleeves that particularly marked the passing of the years. First, in the late 1880s and early 1890s, came the narrow sleeve with a stand-up peak at the shoulder (Figure 73). Then the peak grew rounder and fuller, taking in the upper arm, and ballooning out into the leg-of-mutton shape in the middle of the decade (Figure 1). As the century reached its end, sleeves hugged the arm again and all, if anything, that was left of the leg-of-mutton was a little puffing-out of material at the shoulder. Hair often remained fairly simple, though the fringe became rather rarer. The bun was common, and the last years of the decade saw some inclination towards tresses looped or coiled at the back of the head in shapes that were routinely likened to doorknockers or teapot handles. Emerging and linked trends, which were to become dominant in the Edwardian period, were the wearing of white blouses and the enjoyment of decorative lace.

Aided by corsetry, a rather heavy-busted, full-skirted S-shaped look came in with the first few years of the 20th century, although the more extreme examples of this style tend to belong to fashion plates rather than family photos. Its life was relatively short, for 1909 saw the introduction

of the hobble skirt, which narrowed at the ankles. This could create some difficulty in walking, for the forgetful wearer might step out boldly and cause some damage, so a fetter, tied on at calf-level, was sometimes used to prevent thoughtless movement. Blouses and bolero jackets, which had both achieved some popularity towards the end of the Victorian era, found even greater favour in Edwardian times, and the former were often heavily trimmed with lace. This was well in accord with the taste for soft fabrics and a generally light, summery look (Figures 42 and 74). It was usual for blouses to hang over loosely at the waist until about 1908, after which the garments remained in favour but the bagginess quickly disappeared. Some shock was caused in 1913 with the appearance of the V-necked blouse, which was denounced by clerics as a threat to morals and by doctors as a threat to health. Even very modestly cut garments in this new style were scathingly referred to as 'pneumonia blouses'. Nevertheless, they quickly became widespread.

Hair was now commonly dressed high on top of the head, rather than accumulated at the back, and at the end of the century's first decade the large, wide-brimmed hat became just about universal (Figure 75). Indeed, some highly fashionable hats were wider than the hips, producing a tapering clothes-peg shape which caused a certain amount of merriment. There was some movement back to smaller hats just before the First World War, but headgear resembling a gateau on a plate can still be found in some photographs taken in the early 1920s.

During the First World War, women's clothes were more sensible than fashionable; and skirts, though still long, became fuller and more practical. But peace brought new and rather shocking directions in costume. The 'barrel line' or tubular skirt appeared, and the cut of clothes contrived to minimize curves. The bust, aided sometimes by 'flatteners', disappeared or, at least, was underemphasized. The waist, too, went into an eclipse, with the real or notional belt-line dropping until by the mid 1920s it was around the hips. The resulting boyish look was strengthened by hair becoming straighter and shorter in the form of the bob, the shingle and the Eton crop, each of which was more severe than its predecessor. Around 1925, the short skirt arrived on the international scene. Knee-length or just a little longer, it caused some scandal and, according to one Italian churchman, provoked divine retribution in the form of an earthquake visited upon Amalfi.

In addition to the boyish outline, more easily achieved by some women than others, a variety of other details contributed to the 1920s look. Materials were often light, even diaphanous. Skirts were frequently pleated, and silk stockings were popular. But above all, there was the cloche hat, a close-fitting basin of fabric that echoed the shape of the head. Even when other kinds of headgear are discovered in photographs from the 1920s, there is every chance that they will pay homage to the cloche, for broad headbands and headscarves worn turban-fashion created much the same shape.

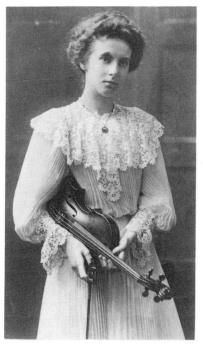 

**Figure 74** Unmounted print; Lena Connell, London (PRO, COPY 1/460)   **Figure 75** Postcard; While You Wait Studio, Croydon

Figure 76, though dating from 1931, provides a good example of the fashions of the 1920s. The body shapes, the low waistlines, the pleated skirt, the hemlines and the hats all speak of a specific period, albeit a period that was about to give way to another.

The cloche lingered on well into the 1930s, but its dominance was weakened. The rather less intense beret won some followers, while small jauntily tilted hats had their own devotees. But it was also becoming more acceptable for women to go hatless, showing off the hair that they were allowing to grow again. There was a return to a more traditionally feminine look, skirts became longer, and the waistline was relocated in its original place (Figure 77). Tailored suits, slim, straight dresses, slender hips and an emphasis on the vertical all found favour. The shoulders were often a point of focus (Figures 40 and 77), with suits cut to give them breadth and dresses that incorporated capes or short frilled 'butterfly' sleeves. Silk stockings were still often in evidence, but synthetic fabrics were being successfully developed and nylons had made their appearance.

The Second World War meant another fallow period for fashion. Clothes rationing was introduced in June 1941, and people needed to make the most of the clothes they already possessed. Influenced at least in part by the kinds of task that some found themselves performing, many young women took to wearing trousers, and the self-indulgent excitement

**Figure 76** Postcard; Charles Howell, Blackpool    **Figure 77** Postcard; photographer unknown

of hats took second place to the practicalities of headscarves and plastic rain hoods. Rather square shoulders, knee-length skirts and sensible shoes all played their part in the 1940s look. If there was a touch of extravagance, it was likely to be seen in the hair, which was usually worn quite long and hanging in waves, perhaps crowned by a hard-won array of carefully permed curls on top of the head.

For men's clothes, a quick tour of some datable highlights may be useful. Before about 1865 there was no strong feeling that upper and lower garments should match, and pale trousers were often worn with a dark jacket (Figures 6, 30 and 66). Peg-top trousers were popular at the beginning of the decade, with wide legs tapering towards the ankles. By the end of the 1860s, the rise of the lounge suit had begun, though the suits of the 1870s and 1880s often looked uncomfortably tight. A rather looser cut prevailed in the last years of the century, when the comfort of jackets was offset by the apparent discomfort of collars, which steadily grew higher (Figure 65), reaching about 3 inches (7.6 cm) by 1899. There was a limited and brief peg-top revival in the early 1890s, at which time turn-ups made their first, short-lived, appearance – only to disappear again until the years immediately before the First World War. Sharp trouser creases, made possible by the invention of the trouser press in the 1890s, are often seen in Edwardian photographs. After the First World War, double-breasted jackets, and sometimes waistcoats, enjoyed something of a vogue.

Influenced by the loose breeches worn by guards officers, generously cut knickerbockers called 'plus-fours' enjoyed some years of popularity (Figure 39). Then in the mid 1920s the very wide-legged trousers known as 'Oxford bags' became all the rage, at their most extreme virtually hiding the shoes. Although custom drew back from such excess for normal wear, trouser legs remained fairly wide throughout the 1930s (Figure 77). Another introduction of the 1920s that was to survive for many years was the Fair Isle pullover. These fancy slipovers may have been admired by the men who wore them, but perhaps not quite so much as by the women who demonstrated their patience and prowess by knitting them.

Men's hats can sometimes help with dating. Until the end of the 19th century, the top hat was quite normal wear. Before about 1865 the crown joined the brim in a straight line, so that a hat placed upright on a table would make contact with the surface all round the brim. With later top hats, a noticeable curve to the underside of the brim was often evident when seen from the side (Figure 66). Bowler hats of the 1860s often had a rather flattened top, whilst those of the 1870s tended to be high-crowned (Figure 78). The more modern look, with medium crown and curled brim, became established in the 1880s. The soft homburg and the straw boater were both introduced in the 1870s, though the heyday of the latter was not to come until the 1890s and the Edwardian years. There was a curiously ambivalent attitude to the cloth cap. Eventually proletarian in its associations, for many years it served as sporty country wear, just the thing

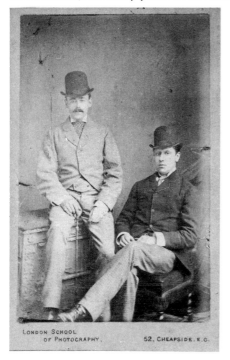

**Figure 78** Carte de visite;
London School of Photography, London

to accompany knickerbockers or plus-fours, and for some time these two social roles overlapped.

One form of male attire that successive wars made common was the military uniform. For most families, there are two points in time when soldiers suddenly make a significant appearance in the album. From a dating point of view, the puttees and tunic jackets of the First World War and the gaiters and waist-length battledress blouses of the Second generally make it easy to distinguish the two conflicts.

A note of warning must be sounded about dating from costume. Some people adopt new fashions quickly; others wait until they are almost disappearing. Very broadly speaking, Londoners, city dwellers, the rich and the young might be expected to take up a new look more promptly than provincials, country folk, the poor and the old. Having bought clothes in a new style, the less well-off would have to make them last longer than the relatively affluent. Dating from costume therefore often leads us to no more than an earliest possible date. Although the beginning and end of a trend may seem quite obvious if fashion plates are studied, real life is generally not so clear cut.

It is a pity, though, if dating so preoccupies us that we miss out on some of the other points of interest that costume can raise. There are occasionally special categories of clothing to be noticed. Military uniform has already been mentioned, but other kinds of occupational clothing, such as railway or nurses' uniforms, are sometimes encountered. However, it has to be acknowledged that for much of the period under consideration Sunday best rather than workwear was the photographic order of the day. Holiday clothes and wedding fashions are also often represented in family collections. The occasions that called for them will be touched on later in the book.

When it comes to social topics, probably none has been closer to the British heart than class. Certainly it's tempting to study photographs for clues to social status, and sometimes it is fairly easy. Between the wars, for instance, waistcoat and collarless shirt were a fairly safe indication of modest standing (Figure 79). But we should be cautious about conclusions we draw from earlier pictures, recognizing that we may be no better at judging social status now than our Victorian ancestors were at the time. After all, employers complained that servants, when dressed for Sunday, were hard to distinguish from their betters. The young woman in Figure 80 is a case in point. She is smartly dressed, neatly coiffed and noticeably, though not vulgarly, bejewelled. There is no obvious sign of coarseness, and no class inference leaps to mind. Then we turn the carte over and read, pencilled on the back: 'this wone is for John if he alike to have it Dow yow think it alike me Elizberth'. This may prompt us to examine the shadows around the eyes for signs of long working hours and early risings to clean the grate. Sagacity comes easily, after it has been pointed in the right direction.

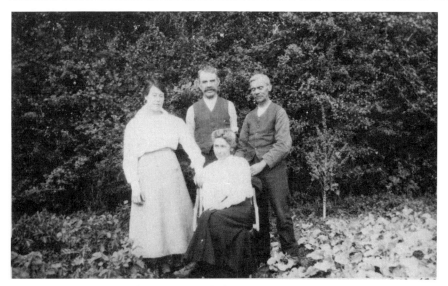

**Figure 79** Postcard; photographer unknown

**Figure 80** Carte de visite;
Friese Greene, Clifton

## Reading the text

Photographers' mounts have been considered from the point of view of design, but the words printed on them may offer further clues to dating. They can also provide some insight into the practitioners' views of themselves: while the portrait itself called upon them to project an image of the client, the mount gave them an opportunity to promote their skills in whatever way they found appropriate.

In the case of the postcard, considerations of dating are the main concern, since its requirement for white space allowed little scope for self-promotion beyond, perhaps, the operator's name and address in fairly small print along an edge. But the largely blank surface of the back can prove informative if something of the postcard's early history is known.

The first postcards devoted the whole of one side to the space where the address was to be written. Any picture or message had to be fitted onto the other side. But many senders wanted to include both picture and message, and in 1902 their needs were accommodated, to a degree at least. The picture was allowed to take up a complete surface and the writing space migrated to the other side, where it shared accommodation with the address space. A line printed down the middle kept the two areas separate. Postal regulations still forbade messages on the address side of any mail that was to go overseas, and users were warned of this by the appearance of wording such as 'For inland postage only, this space may now be used for communications'. After a few years the 'now' in such a reminder came to seem inappropriate, and so tended to be left out. From 1907 onwards, other countries were gradually added to the list of those to which postcards with side-by-side message and address could be sent. Producers of postcards, both ready-made cards and card stock for photographers to print on, responded to these relaxed rules either by trying to summarize the constantly changing situation or by giving up the attempt and simply labelling the halves 'Communication' and 'Address'.

The implications of all this for dating may be readily seen, although it should be borne in mind that it would take a photographer a while to use up a supply of postcard stock, so the last pictures printed on it may carry postal instructions that were already out of date. But a divided back cannot be earlier than 1902; the use of 'now' suggests from 1902 to around 1905 or 1906; and a reference to 'inland postage only' without 'now' might place a card between 1904 and 1907. More complicated instructions, or much simpler ones, belong to 1907 or after.

Cards that have been posted may have a legible postmark, although the date is, of course, that of posting. This may not be the same as the date of the image itself. Where the postmark cannot be deciphered, some help may be given by monarchs' heads and postal charges. Edward VII came to the throne in 1901; George V in 1910; Edward VIII in 1935; and George VI in 1936. Add to that basic knowledge an awareness of inland rates for

postcards and you have a modest aid to dating. Until 3 June 1918 it cost a halfpenny (½d) to send a card. From then until 12 June 1921 the rate was 1d. An increase to 1½d lasted until 24 May 1922, when the cost returned to 1d, where it stayed throughout the reign of George V and on into that of George VI.

It may be that stamps slightly stretch the notion of what constitutes text, though their price is printed on them. But when we move back in time to the mounts used for cartes and cabinet prints, we find that textual information is generally greater and that photographers used it to good marketing effect.

Naturally, some of the information relates to the routine running of the business. There may be something about the services offered by the studio, such as enlarging and colouring (Figures 49, 50 and 51), or directions for obtaining further copies. Follow-up orders were easier to handle if the studio kept records and identified negatives, so serial numbers are commonly found handwritten on the backs of mounts (Figures 81 and 82). Details of prices also sometimes appear, and worthwhile reductions may be offered for bulk buying (Figure 83).

One further piece of trade information sometimes to be seen is the identity of the studio's supplier of mounts. Some suppliers, though by no means all, added their name to the bottom of the mount, with Marion of Paris (Figure 48) and Trapp & Münch of Berlin amongst the most frequently found. Incidentally, the use of a company that appears to be foreign does not necessarily mean that the photographer had scoured Europe for stock. Marion, for instance, was one of the UK's major providers of cameras and photographic materials.

As already mentioned, the text of 19th-century mounts can go beyond the practicalities of business and show the kind of image the photographer wished to project. One understandable wish was to appear solid and well-established, and this could be done by indicating how long a studio had been in business (Figures 17 and 49). But better than just being a survivor was being a survivor with some pretensions to style. There was, in Victorian times, a lively debate as to whether photography was an art or a science. Some practitioners were keen to present themselves as scientists and, like Sawyer & Bird (Figure 33), alluded to particular technical developments with which they were associated. But more photographers were anxious to connect themselves with the world of the painter, which a good number of them had once inhabited and some still did. They wanted to counter the patronizing argument that mere copying by mechanical means, though doubtless quite clever, could not be classed as art.

So, like countless others, F. C. Burnham of Brixton (Figure 50) and W. Spilsbury of West Bromwich (Figure 49). described themselves as 'artist and photographer'. In much the same spirit, Theodore Waltenberg ran a 'photographic art company' (Figure 84) and E. Denney had 'fine art and photographic studios' (Figure 48). Although text itself is the concern here,

**Figure 81** Cabinet mount;
G. W. Wilson & Co., Aberdeen

**Figure 82** Carte mount; G. Absell, London

**Figure 83** Carte mount; A. L. Henderson, London

it should be mentioned that it could be reinforced or even replaced by an image, such as Waltenberg's Junoesque sketcher (Figure 84) or J. N. Paton's easel (Figure 46).

It was also natural to emphasize expertise, and a favoured way of doing that was to boast of honours conferred and competitions won. So A. L. Henderson of King William Street, London Bridge, illustrated his 1880s carte mounts with reproductions of awards won at exhibitions in the United States, Belgium and Australia (Figure 83). The text is there on the medals to be read, though a magnifying glass is needed for some of it. It may also be noticed that Henderson's highly personalized mount demonstrates that designs could be bespoke or customized.

There is one other feature of Henderson's mount that demands attention, and that is the accolade 'By appointment to the Queen'. He was granted the royal warrant as photographic enameller on 21 November 1884. This information, of course, helpfully gives an earliest possible date for the carte. But it also serves to introduce another popular form of self-promotion – the claiming of eminent patrons. The fact that a studio was good enough for the great figures of the day might well convince the prospective but undecided customer.

Not everybody could inveigle royalty into the studio, and some photographers had to make the most of modest local connections. Others, like W. Audas of Grimsby, accumulated an impressive catalogue of notables

**Figure 84** Cabinet mount; Theodore Waltenberg, London

**Figure 85** Cabinet mount;
W. Audas, Grimsby

(Figure 85). He was able to boast of three Royal Highnesses and two earls in a list where anybody less than a member of parliament was a mere etcetera.

Members of the royal family provided the most desirable names to drop, and strict honesty was not always the policy. Those who were tentative in their presumption might, like F. C. Burnham (Figure 50), W. Spilsbury (Figure 49) or J. Nott (Figure 47), content themselves with imagery suggesting royal associations. Others actually used words to suggest or claim an official status which was not theirs. Eventually, in 1884, a token prosecution was brought against A. & G. Taylor for their unauthorized use of the royal arms and the problem was brought under control.

Whilst far more photographers claimed royal appointment than enjoyed it, Henderson's carte serves as a reminder that what glitters is sometimes gold. Another such example is provided by Figure 57, a cabinet print from the Aberdeen studio of G. W. Wilson & Co. The arms displayed on the back of this picture (Figure 81) are quite in order. George Washington Wilson was granted a royal warrant in 1873. His sons carried on the business under his name and the company received a second warrant in 1895.

The most remarkable claim to high connections, albeit implicit, was made by John Beattie of Clifton. Perhaps in the same spirit that encouraged J. R. Sawyer to use 'Sol fecit' as a motto, Beattie adopted the

phrase 'Fiat lux' for his 1860s mounts. Whether he thought he was quoting the Almighty or setting himself up as an equal is not clear, but any delusions of grandeur were rather dashed by the printer's misspelling of the tag as 'Fait lux'.

Claims to artistic distinction, competitive success and an exalted clientele should not blind us to one further textual feature which, though mundane, can give valuable assistance in dating photographs. The address of the studio, or studios, can sometimes be helpful, since businesses changed hands, individuals acquired and gave up premises, and partnerships were formed and dissolved. Such comings and goings were recorded in trade directories, which may reveal that the address or addresses given on a mount remained valid for only a relatively short period of time.

Thanks to competition between publishers, directory information about a photographer was sometimes updated at as little as one- or two-year intervals. However, details were usually collected well before a directory appeared and were sometimes already out of date at the time of publication, so dating conclusions must be approximate. Sifting through a succession of trade directories can be time-consuming, but you may find that somebody else has already done the work and presented it in the form of a directory of photographers for a particular city or county. A number of these have been produced for the Royal Photographic Society and a few others have been published. Often, though, there will be no short cut that is readily available.

Although it is always possible that the photographer under investigation worked for many years at the same address, using trade directories, either at first or second hand, can often prove rewarding. Figures 86 and 82, for example, show the two sides of a carte by G. Absell of 45 Newington Causeway, London. The picture, with its full-length figure, its simple chair and its interior-to-exterior backcloth, looks as if it belongs to the 1860s. But it is always reassuring to have confirmation. In his invaluable *Directory of London Photographers 1841–1908*, Michael Pritchard notes only this one address for Absell, and the approximate date range he gives is 1864–5.

Figure 87 shows a cabinet print by Banger of Exchange Street, Norwich. It has a blank back, but the address below the image is all that is needed. From the late 1880s Edgar Banger worked in partnership with John Gavin, then at some time between the 1892 and 1894 trade directories the pair went their separate ways. Gavin remained at the St Giles Street studio, while Banger set up in business at Exchange Street, where he continued at least until information was collected for the 1896 directory. By 1900 he had moved to St Benedict's Street. The cabinet print of the young boy can therefore be ascribed to the 1890s, but not to the earliest years of the decade.

More precise dating can be attempted in the case of Figure 51. The mount is that of Charles Weale, who between 1888 and 1890 took over

**Figure 86** Carte de visite; G. Absell, London

**Figure 87** Cabinet print; Banger, Norwich

the studio at 4 London Road, King's Lynn, from Edwin Mowell, who had worked there for most of the 1880s. But the name of John Henry Hall has been overprinted on the mount. Hall appears as the photographer at that address in directories for 1891 and 1892, but then vanishes. The carte must therefore belong not merely to Hall's relatively short tenure of the studio but to the very early part of it, when he had just taken over and had not yet had his own mounts printed.

# 5 A Family Record

## Life and events

The story of a family can be much easier to read from a lovingly filled album than from a heap of photographs crammed into an old shoe box. However, even an album that faithfully records the family's autobiography may present problems, as the way it has been ordered and maintained can cloud issues of identification and dating.

Some of our forebears were careful to identify the people they included in their albums and meticulous about recording events and dates. But most of them, like most of their descendants, were not. So we may not always be certain who we are looking at. This, of course, is where dating photographs can help. Determining, say, that the subject was little more than a child in the 1870s, rather than the 1860s or 1880s, narrows the range of possible identities. But there may be figures in the album who thwart our attempts to place them and turn out not to be family at all. Friends, the vicar and a few eminent personages may well be represented alongside the great-great-grandparents and the second cousins three times removed.

Further problems with reading an album may be caused by the way the photographs have been arranged. Pictures may have been inserted chronologically, filling the book from front to back in the order in which they were taken or acquired. They may, though, have been organized by relationships, with different branches of the family each being treated to a few pages of their own. Or they may even have been ordered to satisfy the eye. The French album from which Figures 45 and 56 are taken tends to group similar subjects on two-page spreads, displaying a number of children or young women or vignettes together. Even when chronology is the underlying principle, it may not have been strictly adhered to. As mentioned earlier, from the 1870s until the end of the 19th century many, perhaps most, albums had precut apertures for a mixture of cartes and cabinet prints. But life did not necessarily produce a series of photographs that combined the two formats in quite the proportions and order the album ordained. At best, each series of the two sizes of aperture would be filled at its own rate.

Nevertheless, however incoherent the record may seem, a family's collection of photographs is still likely to tell, in more or less detail, its

communal story. We will find the new babies, the children growing up, the young maturing, and the adults growing old. We will see the family milestones – of which the weddings will perhaps be the best represented – and the family at leisure, with holidays predominating. Working life will not be much in evidence, except perhaps where it involves the wearing of a uniform; and everyday chores will seldom, if ever, be recorded. Apart from formal visits to a studio, the indoor world will scarcely figure until we come to pictures from the second half of the 20th century, so life will seem to be full of trips to the sea with never a Christmas to separate them. The prevailing mood of the pictures will no doubt undergo a change, becoming more relaxed as time goes on, but we will need to remind ourselves that mood has as much to do with the respective technologies and conventions of studio and snapshot as with the individual people depicted.

As historical records go, family albums tend both to lack objectivity and to be highly selective (though coverage generally improved from Edwardian times onwards, as people acquired their own cameras and tried photography for themselves). But then, detachment and unflinching thoroughness are not always to be expected from an autobiographical record.

The impression we gain of Victorian domestic life is likely to be very limited, though cartes de visite and cabinet prints taken out of doors (and apparently in the subject's garden) are sometimes found. But once people began to wield their own cameras, house and garden became and remained favoured settings for photographs (Figures 13 and 40). Until the widespread use of flashbulbs, the average amateur could have no hope of finding adequate light for interior shots, and the nearest to indoors that the camera could reach was the threshold. But that served well enough, and pictures of family members posed on the front step were particularly popular in the early years of the 20th century, when the ability to capture even the outside of the house was still something of a novelty.

Landmark events are likely to be rather better represented than the day-to-day occurrences that filled the gaps between them. There may, though, especially in the case of 19th-century pictures, be some difficulty in recognizing them for what they are. The modern candles on the cake or balloons on the gate are more readily identifiable than a birthday visit to the studio. Sometimes clothes or accessories offer a clue to the occasion. People wearing uniform or chains of office may well be showing off a role or status that is newly acquired. Similarly, if a young woman's hands are carefully arranged to allow a ring to be noticed (Figure 16), that could be a sign of an engagement or wedding. Portraits were often taken as mementos of such events, though the quite common practice of photographing the couple separately can obscure their significance to our eyes. We may also be thrown off the track by changes in the importance attached to certain events. Had Figure 60 not been conveniently captioned, it might, in a less pious age, be taken to show a nun in the family, rather than a confirmation.

As remarked earlier, of all the milestone events that feature in the family album, weddings tend to be the most prominent. As in other areas of fashion and photography, royalty led the way, though not quite at once. At the time of their marriage, photography was in its infancy and Queen Victoria and Prince Albert had yet to realize its possibilities. By 1854, however, their enthusiasm had been aroused, experiments were being undertaken in a royal darkroom, and Roger Fenton was, belatedly, summoned to take the couple's wedding pictures. The clothes worn on the original occasion were brought out and put on, and a rather touching set of photographs was taken, 14 years after the event.

But for most people, a home visit by the photographer was out of the question. The wedding pictures, if attempted, necessitated a visit to the studio, either on the day of the event or perhaps on a day close to it. This was the practice during the Victorian period and the first years of the new century (Figure 20). Only the most vital performers were called upon to attend, for the relentless inclusion of everyone present at the event is something that has grown up over the years. Best clothes were certainly worn, but the bride's white gown was not yet absolutely routine and she might be as readily picked out by the flowers she carries as by a snowy frock.

The Edwardian age marked an overlapping of practice. The studio wedding portrait had not disappeared, but the outdoor picture was becoming established. It made the inclusion of a larger wedding party easier to manage, setting a trend that studios, when still used, came to follow. It also had an air of immediacy. In its own limited way, wedding photography was becoming a form of documentary photography. The studio camera marked the event, but the outdoor camera recorded it (though pictures at the church door did not become common until the 1920s, and both lighting considerations and notions of decorum discouraged pictures of the actual service until the second half of the century).

Three examples have been chosen as a sample of non-studio wedding photographs. The earliest (Figure 88) dates from Christmas Day, 1913, and records the marriage of Eliza Ruppersberg and William Tarrant. The picture has apparently been set up in the back garden, into which the cake has been brought to be recorded for posterity. Although (as the groom's lounge suit suggests) the wedding is that of working folk, nobody could ask for a more impressively decorated cake. But then, the bride came from a family of master bakers, and the cake is an expression of both family love and professional pride. The new wife, according to custom, changed her surname to that of her husband. It is a sign of the sensibilities of the times that, when war broke out, the rest of her family found it expedient to change their name, too.

The two later examples remain anonymous. The first (Figure 89) has 'To Mabel & Harry' written on the back. The setting is, once again, a

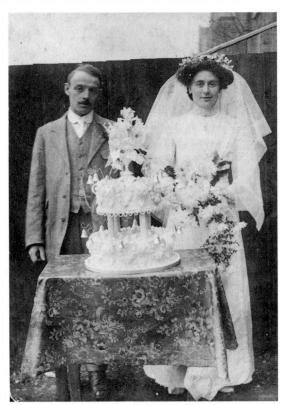

**Figure 88** Unmounted print;
photographer unknown

garden, though a rather more spacious one, which affords a pleasantly rustic backdrop. The ground has been covered with a carpet, which means the children can sit without risk of grass stains on their clothes, but the effect of an indoor floorcovering against a leafy background is curiously reminiscent of the Victorian studio. It almost seems a case of nature imitating art. The hats, with their variations on a basic basin-shape, and the evidently less than floor-length dresses all point to a date in the 1920s. That some degree of informality was acceptable by that time may be deduced from the men's patterned ties. Whilst the exact year is not known, the time of year is, for it was clearly a high-summer wedding. Flowers in bouquets can be unreliable witnesses, as it is hard to know whether they have been forced; but flowers in the earth are a different matter, and a pleasant show of hollyhocks is in view at the left of the picture.

This sampling of wedding photos ends with the 1940s (Figure 90). The fact that the groom is in uniform helps towards dating, but so do the bride's permed hair and accentuated shoulders. She is not wearing a romantic white gown, and there are a number of possible reasons for this. Suitable fabric was hard to come by, and many brides' hopes of finery were only realized thanks to the acquisition of some parachute silk. Then again, the wedding may have taken place at a registry office, as increasingly

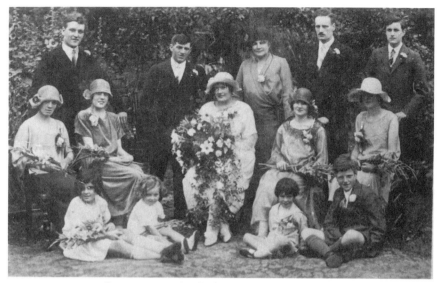

**Figure 89** Postcard; unknown East London photographer

happened from the Second World War onwards. Less dramatic attire was generally chosen for such venues. Or this could be a second wedding for one or both of the participants, and second weddings were often more muted. Certainly the couple appear to be of reasonably mature years. Divorce, today's most common precursor to remarriage, was less of a habit in the 1940s, but war provided ample opportunity for the other precursor, death. But, however low-key the occasion may have been, the bride is still marking it by carrying a horseshoe. The groom, too, lacks finery, but weddings in uniform were not unusual and they were sometimes hasty affairs, arranged to fit into a short leave. The closest he comes to marking the occasion is indulgence in a celebratory cigarette. There may, though, be another manifestation of the event. There are some white spots on the picture, most of which are undoubtedly blemishes – but there does seem to be a particular accumulation of such specks on all four shoulders, and that kind of concentration rather suggests confetti.

The desire to photograph weddings has survived and grown. But we show greater coyness than our ancestors in the matter of death. That is, perhaps, because we are able to distance ourselves from it for more of the time. Longer life expectancy means that death has come to seem a less routine occurrence for us, and we respond to it differently. Perhaps we are less sentimental and decline to dwell on death; or perhaps we are more embarrassed by it, and seek to brush it away. Our predecessors embraced mourning, dressing to demonstrate their grief, and modifying their clothing by degrees over a period that could last for up to two years. The dull, rough-textured look of black crêpe can sometimes be seen in old pictures, as can the wearing of chunky, gleaming jet jewellery.

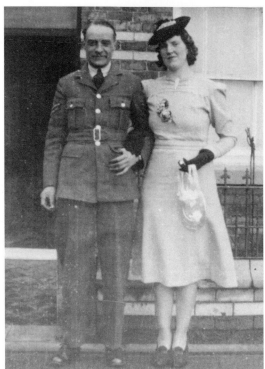

**Figure 90** Postcard;
photographer unknown

A familiarity with family history may enable us to decide who is being mourned, or may help us to date a picture to shortly after a specific death. But we can jump to the wrong conclusions. Some people, most notably Queen Victoria, exceeded the standard two-year period of mourning; and many mourned quite distant relatives and friends, whose deaths we might not be aware of. Jet can be misleading, too. It was used for jewellery before its association with mourning, and it never quite gave up an existence independent of death, enjoying a period of particular popularity in the 1890s. It can, therefore, be difficult to know what to make of it when it appears in photographs, and the supporting evidence of crêpe should probably be sought before conclusions are drawn.

But there are pictures more explicitly related to death than those which simply show people in mourning. Earlier generations used photography as a bereavement aid. When death was a more frequently encountered occurrence, and when it was not unusual for children to die in infancy, there was comfort in having something to hold on to after a loved one's departure. So photographs were taken of graves and of the deceased. We are no longer comfortable with such pictures, and I confess to some unease when looking at the photograph of 'Uncle Charlie's funeral, 1916' (Figure 91), even though it shows the coffin of an adult, rather than the more disturbing corpse of a child. But it may be that in confronting death, rather

than trying to sweep it aside, our ancestors were wiser and less ghoulish than we think.

A rather more cheerful kind of event that tends to be well represented in family collections is the holiday. Here, as with weddings, the earliest examples are studio photographs. They may show us more of the scenic artist's skills than of the seaside, but they still have things to tell us.

Figure 92, for instance, not only shows us the formality of holiday wear in the latter part of the 19th century; it also hints at the subjects' class. There were many people for whom a day at the sea constituted a holiday. Bank Holidays, instituted in 1871, gave a major boost to day-tripping, but few people could afford a longer treat than that. As a result, a kind of class distinction between resorts grew up. Those that were most accessible attracted the lower orders, who had less time to spend. Places like Ramsgate and Margate thus became loved by the masses and shunned by the select. 'Look at these sands!', shuddered Elizabeth Stone in *Chronicles of Fashion*. 'They appear one indiscriminate moving mass of cabs, cars, carts and carriages; horses, ponies, donkeys and boys; men, women, children and nurses; and the least and the biggest – babies and bathing machines.' So the more moneyed and leisured classes moved further afield, to rocky coasts and resorts at a distance from the major towns. Figure 92 was taken in a Cornish studio, and Cornwall preserved a degree of remote gentility until well into the 20th century.

Once holidaymakers could routinely take their own cameras with them, rather more informal images were recorded. The world was moving on. In

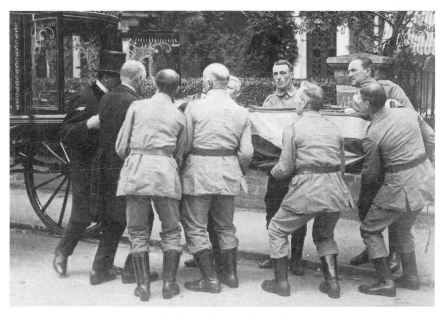

**Figure 91** Postcard; Mrs G. Swain, Norwich

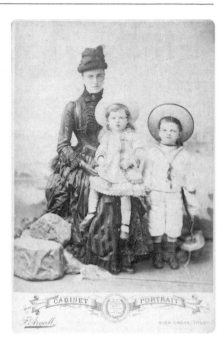

**Figure 92** Cabinet print;
Frederick Argall, Truro

particular, the more relaxed attitudes that followed the First World War often speak eloquently from the pages of the family album. We may be able to observe some of the changes in its pages, noticing the shift from bathing machine to bathing tent that began in the early years of the century, or the growth of holiday camps in the 1930s.

Change does not, of course, happen at a uniform rate. Some of us embrace it more readily than others, as two snapshots from the same 1932 holiday in Hastings show. Figure 93 records two couples of the same generation. All are well wrapped up for a summer's morning. (The time of day can be deduced from the south coast location and the shadows falling to people's right.) But one of the men is rather more formally attired than the other. Not everyone in 1932 wore a bowler to the beach.

Two of the figures reappear in Figure 94, this time in the company of a group of young men who are clearly in the holiday mood. The open-necked soft-collared shirts, the jaunty sailor hat, the pale and sporty pullover and the apparently wide-legged trousers are all of their time and place, though the striped top of the belted swimming costume may have tended towards the slightly old-fashioned. Swimming trunks were beginning to make an appearance, and it could be that the youth to the right of centre is wearing them beneath his towel. But, despite the bared chest, the young man to the left of centre is not quite so avant-garde. His costume still has a torso section, which has been pulled down for the purposes of drying (or bravado), and which overhangs the top of his towel. The posed jollity is as characteristic of snapshots as solemnity is of the

**Figure 93** Roll-film print; amateur photographer

**Figure 94** Roll-film print; amateur photographer

studio portraits that preceded them. Everybody is intent on having a visibly good time, and the smiles, hat and cigarettes are supplemented by the arm around neck and the beach ball on head. Holidays, we are invited to agree, are a great lark.

Amusement was being anticipated in the same year at Ramsgate when Figure 95 was taken. But it was being anticipated quietly. On this occasion

**Figure 95**  Postcard; A. Bennett, Ramsgate

the photographer was a promenade professional, who caught this family striding out with pleasure in mind. There is, I think, nothing in their dress and little in their manner to suggest a quest for fun. There is, admittedly, no bowler hat, but the figures could just as easily be bound for church or the dentist as on their way to enjoy a seaside leisure facility. Nevertheless, on the back of the postcard is written: 'Much love from us all. Taken on Sunday May 15th 1932 on the way to the putting course.' The soberness of dress may, of course, have something to do with the day of the week, but it is also true that the English have a long-established reputation for taking their pleasures seriously.

## Roles and relationships

When family roles are considered, it must be admitted that we are dealing largely in stereotypes. We may not presume to know from a photograph just what sort of person an individual was, but we can comment on the kind of image that the subject and the photographer, between them, conveyed.

The first character that comes to mind when considering the household cast list is, inevitably, the Victorian father. Traditionally grave of mien and frowning of brow, his part was that of unquestioned domestic ruler and he might exercise that role more or less despotically. The apparent severity of the father in Figure 7 is not the only expression of which paternal power is capable. The man in Figure 96 is less forbidding. He still embodies all the requisite values, but there is a hint of softening about the mouth and eyes which suggests that in his case authority might be wielded with a dash of benevolence.

Beside or behind the paterfamilias stood the mother, a fount of womanly wisdom, soft sympathy and unswerving support. So the husband in Figure 97 sits four-square and solid, gazing intently ahead, attended by a wife who adapts to his mood as she does to his wishes. She is a tower of matronly strength, but not a competitor for the only chair.

The Reverend Charles Lutwidge Dodgson (Lewis Carroll) had some fun with such stereotypes when, in the metre of Longfellow's song of *Hiawatha*, he described a family sitting for portraits. First came 'the Governor, the father':

> He would hold a scroll of something,
> Hold it firmly in his left hand;
> He would keep his right hand buried
> (Like Napoleon) in his waistcoat;
> He would contemplate the distance
> With a look of pensive meaning,
> As of ducks that die in tempests.
> Grand, heroic was the notion.

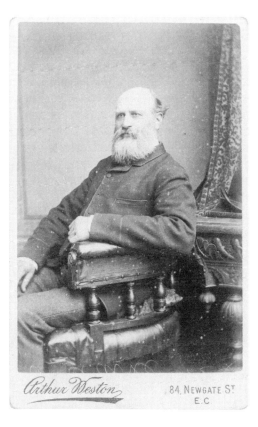

**Figure 96** Carte de visite; Arthur Weston, London

Then his 'better half' took courage:

> She came dressed beyond description,
> Dressed in jewels and in satin
> Far too gorgeous for an empress.
> Gracefully she sat down sideways,
> With a simper scarcely human,
> Holding in her hand a bouquet
> Rather larger than a cabbage.

The children fare little better. The elder son, an avid reader of Ruskin, demanded aesthetic treatment; the daughter required the photographer to catch her look of 'passive beauty'; and the small boy proved 'very fidgety'.

It is interesting to observe what happens when members of the family dramatis personae are brought together. Not surprisingly, when pictures of 19th-century couples are inspected, it is the male who tends to dominate. When the wife's hand is touching the husband's shoulder, it is expressing support or seeking protection. When his hand is on her shoulder, there is something protective or proprietorial about his manner. If he seems not to notice her, it is because he has other things on his mind. If she doesn't look at him or follow his gaze, it is because she knows her place. When one of them is sitting and the other standing, the male still seems to dominate, no matter which combination of positions is chosen. If he stands and she sits, he has the advantage of extra height, and that adds to his presence and authority. But if he is the one who sits, he is part of a tradition in which it is always the officer, the team captain or the headmaster who has the chair, while lesser mortals stay on their feet (or, in some cases, sit on the ground).

So, the wife in Figure 97 stands in attendance. She is the man's right hand, though placed at his left shoulder, and the position of her own right hand seems encouraging and supportive. But although her pose relates her to him, his is wholly independent of her. There is no sign that he is aware of her presence, and he could adopt precisely the same position, and to the same effect, if he were alone. In Figure 98 a similar arrangement is seen. The young husband stares, full-faced, out of the picture in a pose that is in no way modified by the presence of his wife. Her secondary importance is suggested not just by the fact that she is standing, but also by the angle of her body, turned towards him and partly away from us. Her hand is much more tentatively placed than that of the wife in Figure 97. It appears to rest on the back of his chair and does no more than brush against his sleeve. She has something of the air of diffident accessory.

In Figure 99, it is the wife who is seated and the husband who hovers in attendance. There is a demureness about her gaze. She doesn't meet the camera's eye and seems enwrapped in peaceful thoughts. He, on the other hand, relates very firmly to her, resting his right forearm on her chair and gripping it with his left hand. His body leans slightly towards her and he

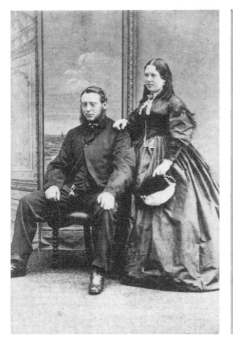

**Figure 97** Carte de visite;
Beckett and Willis, Scarborough

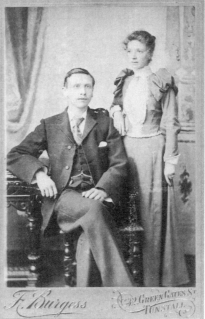

**Figure 98** Cabinet print; F. Burgess, Tunstall

**Figure 99** Carte de visite;
William Cobb, Ipswich

looks at her fondly. To be more precise, he looks down at her fondly. The pose undoubtedly suggests affection, but it also suggests ownership.

Something a little different is presented in Figure 73. It could be that the difference has to do with the picture not being British, but I suspect not. When, in speaking of values and conventions, we use the word 'Victorian', what we often mean is '19th-century European'. The significant factor in this photograph may rather be the age of the couple, for they seem very young. She adopts the conventional hand-to-cheek pose and has about her a scattering of flowers, traditional symbols of feminine beauty. The book does its usual job of suggesting a thoughtful nature, and there might be additional significance in its title, if only it could be made out. But the overall impression is not of timid submissiveness, for the young woman's eyes are firmly focused and she seems at ease and assured. The young man, by his hand on her chair, claims her for his own, but he is following her glance, against the angle of his body, and he seems to be offering the ghost of a not particularly confident smile. In short, despite his potentially possessive pose, he doesn't quite dominate. It may be that he is still learning, and that his left hand provides the necessary clue. His ring catches the light and provokes the thought that we could be looking at a wedding picture. But, whatever the occasion, the image has an appealing naturalness and charm.

In old photographs the relationship between parents and children can provide material for speculation, too. The apparent grimness of the father in Figure 7 has already been commented upon. But what of his son? He has a hand on his father's shoulder, but plenty of daylight can be seen under the arm, which is held well away from the body and seems almost divorced from it. The cross-legged stance was often used by young men in full-length poses of the 1860s, and may be supposed to suggest a debonair man-of-the-world quality. Sometimes it may have had an element of bravado to it, demonstrating that here was somebody who could keep still without the use of artificial aids. Sometimes, though, as here, it undermines its own stylishness by betraying the feet of a headrest. In all, this lad's attempt at insouciance is not very effective. No clear sense of the relationship between father and son comes across, and it may be that the picture says as much about 1860s studio conditions as it does about family ties.

The mother and two children seen in Figure 12 seem slightly more at ease in each other's presence, though all stare steadily towards the camera. William Reid's hand on his mother's shoulder seems more challenging than loving, as if he is making an arrest, but his body is close to hers. Jeannie leans towards her, with hand tucked through her arm. The stiff and uncomfortable feeling seems to arise from the photographic occasion rather than from the relationship between the three. Like Figure 7, the picture was taken at a time when being photographed was still something of an ordeal. With the Reid family, the result appears to be a feeling of unity in adversity.

The sense of a physical link is stronger in Figure 100. The mother is clasping the small child securely, not cuddling it close to the body, but holding it forward, at the front of her lap, in order to display it to the camera. The older child clasps its hands together and finds security and reassurance in leaning against its mother. It is a scene that achieves a sense of close relationships, while still ensuring that the camera has a good view of each subject. What unites the three more than anything, and brings the picture alive, is the success of the photographer in focusing attention. Not only are the two children absolutely intent on whatever is happening, but their mother, too, seems riveted by it.

Sometimes, though, there can be a sense of subjects performing for the camera. Figure 101 presents maternal love in an idealized form, with mother and child shown cheek to cheek with fingers tenderly entwined. But Madame Rupell is dressed for a social world in which feeding and changing babies has no place, and the viewer feels confident that once the sitting is over the infant will be handed back to someone who is paid to look after it.

When we see siblings together, without an adult in the picture, the tendency is still towards formality. Between small children a sense of affection may be shown, especially if the picture is of a young child exhibiting a new baby. But when they are not much older, we find the young behaving with the same reserve and dignity as their elders. In Figure 3, for example, the hand on the shoulder is a routine gesture that may symbolize closeness but doesn't express it with any great assurance. The hierarchy of age, which can be important to siblings, is adhered to, for the older sister is seated, while the younger stands at her side and slightly further back. (To be fair, it should be noted that the arrangement could have been influenced by aesthetic considerations. It is possible that the height difference between the two girls would have been greater if both had been standing; it would certainly have been greater had the younger one been sitting. So the deployment of sitters may have been intended to bring the two faces closer together and give a tighter composition.)

Figure 102 shows a brother and sister together. They seem close in age, though he is a little taller, and they are both leaning against the same piece of studio furniture. But the closeness goes no further. Each could just as well be posing for a solo portrait. Although elbows are close, they do not quite touch; and their owners are on opposite sides of the fence. What we are looking at is two quite independent beings who just happen to find themselves occupying the same space.

The occupation of space is often an important concern when we turn to family groups, for a basic problem was how to fit everybody into the picture comfortably. In Figure 103 there has proved to be sufficient room, and the camera has been able to retreat far enough to get everyone into frame and even to allow a little modest vignetting. But this has made nonsense of the backcloth, which is just not wide enough for the occasion.

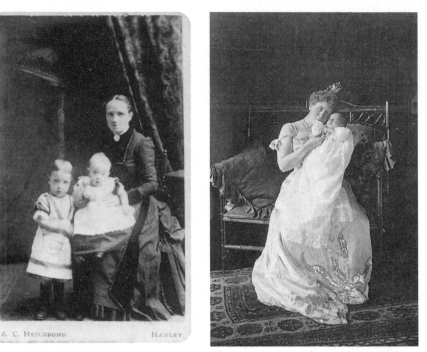

**Figure 100** Carte de visite;
A. C. Heilbronn, Hanley

**Figure 101** Unmounted print; Edwin Debenham,
Gloucester (PRO, COPY 1/453)

It works well enough in normal circumstances, as can be seen in Figure 98, but it wasn't made to accommodate eight people, so in the group portrait both edges are visible and expanses of wall and door are revealed.

The group in Figure 103 is made up of parents, five sons and a daughter-in-law. Her position in the family may be deduced in part from the role she plays in Figure 98. This is confirmed by a survey of the album from which both pictures are taken, which shows several youthful photographs of the man beside her, whilst she makes no earlier appearance in its pages. The parents take the chairs that seniority earns, and the youngest son is placed on a low seat between them. The importance of the elders cannot be mistaken, but they carry it quite lightly: the mother smiles gently and the father leans slightly towards the centre, in a pose that seems confident without being rigid. The other young people have been grouped behind them, and attention has been paid to their height, so that the line of heads rises and falls in a pleasing curve. This does have the effect of putting the in-law on the periphery, which might well be thought appropriate, but it also makes for an agreeable composition. The begetters of the line are made the centre of attention; the youngest child is specially indulged; there is a satisfying balance in the positioning of the parents' arms and hands; and the vignette effect echoes the oval shape of the group as a whole. If the background is ignored, the result is a very effective group picture.

**Figure 102** Carte de visite;
William Wyatt Burnand, Poole

There is one further line of thought to be pursued, for group photos offer us the chance to look for family resemblances. It is hard to link the three older sons with either parent. If the father had more hair and a more visible mouth, some element of likeness might be apparent. As it is, all we can say is that the outer two of the three young men seem to have some mutual resemblance beyond the wearing of a moustache. The two youngest sons, however, take after their mother to a noticeable degree. It is possible that one of the parents has brought to the family sons from a previous union. The remarriage of widows and widowers is a common enough occurrence, and to find a reflection of this in photographs would not be surprising.

Once the camera moved out of the studio and into the hands of amateurs, more relaxed images, more cheerful moods and more demonstratively friendly relationships became the everyday stuff of photography. There was often a sense of spontaneity, as in Figure 39, with the subject walking along the street; or Figure 69, where the subject pauses on the way back from the paper shop. In both cases the surroundings were undaunting, the photographer was familiar, and the mood relaxed. There was no need to assume a persona or project an image: if any subtext was present, it is more likely to have been concerned with contentment than

**Figure 103** Cabinet print; F. Burgess, Tunstall

with the traditional values of dignity and respectability.

This increased sense of naturalness found expression in group as well as individual pictures. In Figure 79, for instance, there is no sense of structure to the group. On the back of the picture is written 'Tom Shierer and family', but just what the relationships are is not clear. We appear to be looking at two couples, and the gaze of the man on our right seems to link him with the woman sitting on the chair, though he may be looking down, rather than at her. We can make guesses about the relationships, but there is no inbuilt visual hierarchy. In Figure 13 the relationships are clear enough, but the organization of bodies makes the mother the centre of attention whilst relegating the father to the sidelines. He is, admittedly, the tallest person present; but, as with his children, we see him in relation to the person who is seated. The generally relaxed mood is partly suggested by a sprinkling of smiles, but it is also helped by the informality of the grouping. To be convinced of this informality, imagine drawing a single line connecting all the noses in the group and compare the resulting shape with that of a similar line drawn on Figure 103.

When affection is shown in 20th-century pictures, it is likely to be shown unequivocally. Instead of deciphering the message conveyed by a tentative hand on a shoulder, we may be confronted with an amiable sprawl of limbs. Figure 104 – which comes from the same collection of glass negatives as Figure 13 – provides a good example, though it must be acknowledged that on this occasion a mixture of family and friends is

**Figure 104** Modern contact print from original amateur glass negative

represented. The gaiety of the occasion is immediately apparent, but we find ourselves wondering how long such gaiety would last for the two men in uniform, one of whom, minus cap, is presumably behind the camera.

In all our musings about relationships and feelings we should, of course, bear in mind that the 20th century did not invent naturalness. Limited manifestation of emotion in old studio photographs does not necessarily mean that our ancestors lacked affection. Amateur Victorian country-house photographers were, despite long exposure times, able to catch the informal moods that the professionals were, by and large, not aiming to convey. Studio pictures were usually more concerned with showing a public rather than a private face. Absence of evidence is not evidence of absence; in commercial studios, at least, sleeves were for the covering of arms rather than the wearing of hearts.

## Childhood and growing up

If there is any truth in the generalization that our ancestors preferred children to be seen and not heard, it is also evident that they delighted in the seeing, and they stage-managed it with some panache.

The Victorian and Edwardian leisured classes developed something of a taste for fancy dress generally, and they were known to give free reign to this taste in their photographs of children (Figure 105). Julia Margaret

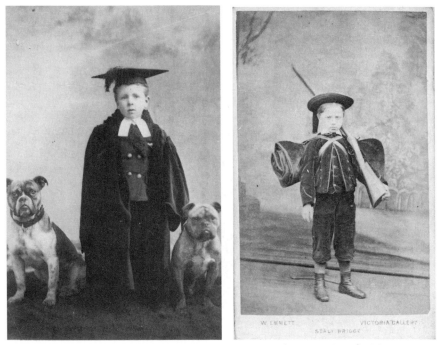

**Figure 105**  Unmounted print; James Soame junior,
Oxford (PRO, COPY 1/396)

**Figure 106**  Carte de visite;
W. Emmett, Staly Bridge

Cameron turned them into angels, cupids and John the Baptist, while the Reverend Charles Lutwidge Dodgson (Lewis Carroll) created a beggar girl and Japanese maidens. The royal children were constantly dressed up for the camera, with footmen, shepherdesses and the Four Seasons as just some of their photographic incarnations. Prince Arthur seems to have been the subject of more than his fair share of adult inventiveness, appearing variously as a drummer boy, a Sikh prince and a Raphaelesque putto. But it is Prince Arthur as Autumn, in leopard skin and long-sleeved vest, that perhaps wins the prize for improbability.

The young lad of Figure 106, off to war with rifle and backpack, is a muted studio echo of this kind of picture. The setters and arbiters of fashion might be able to contrive quite elaborate tableaux, but the family album is likely to show more modest flights of imagination, set against a standard (and possibly creased) backdrop. For ordinary people, occasions for fancy dress were not routine and inventiveness was not at a premium. Their time, perhaps, needed less filling.

But there were exceptions. Special events could provide special stimulus and opportunity; and the street parties of summer 1919, held to mark the Versailles Peace Conference, seem to have brought out young and old alike in a rash of colourful costume. It was at just such a celebration that the little girl in Figure 107 appeared as a Red Rose, in a costume made by

**Figure 107** Postcard; photographer unknown

**Figure 108** Carte de visite;
A. C. Heilbronn, Hanley

sewing petals of crêpe paper to a simple shift. Her older cousin went as a Pink Rose, and their mothers were swathed, Britannia-like, in Union Jacks.

For everyday purposes, however, more serviceable clothes were needed. But that did not wholly crush the desire to dress children up, and a number of juvenile-fashion idioms developed and remained current for many years. It was, for instance, common to dress siblings of the same sex as matched sets. Sailor suits (Figure 108) were enormously popular for decades. That royal example helped to keep them in vogue is shown by Figure 109, a 1903 portrait of the Princes Edward and Albert – later to become Edward VIII and George VI. Aided by the royal family's promotion of a visual Scottishness, tartan (Figure 27) enjoyed a long period of favour, too, and even crossed the Channel (Figure 56).

One style that now strikes us as especially Victorian, perhaps because of the sentimentality involved, is the Little Lord Fauntleroy look (Figure 110). Frances Hodgson Burnett's novel *Little Lord Fauntleroy* appeared in 1886, after serialization that had begun in the USA during the previous year. It placed before the reading public Cedric Errol, 'a graceful childish figure in a black velvet suit, with a lace collar, and with lovelocks waving about the handsome, manly little face'. The child was a paragon of sweet perfection and, even as a baby, 'his manners were so good . . . that it was delightful to make his acquaintance'. The character was based on the author's own son,

**Figure 109** Unmounted print; Frederick Ralph,
Dersingham (PRO, COPY 1/460)

**Figure 110** Carte de visite; Thompson,
Amesbury, Massachusetts

Vivian, whose photograph was the starting point for Reginald Birch's
original illustrations. The book and its subsequent stage adaptation were
enthusiastically received in the States, Britain and mainland Europe, and
an orgy of merchandizing followed. There were Fauntleroy playing cards,
toys, stationery and chocolate, and the novel's publication was followed by
a widespread fashion for dressing small boys in velvet and lace. Mothers
were charmed by little Cedric, who had a 'loving little heart' and who
addressed his Mama as 'Dearest'. So they dressed their own sons in his
image and were delighted with the results. The universal delight of the sons
is less certain.

The sentimental idealization of children that informed the Fauntleroy
fashion was part of a much more general attitude. But before we take our
forebears to task for their saccharine sanctification of the very young, we
might remind ourselves of its function. High child mortality was a fact.
Any sizable family might expect to lose an infant or two, and having a
large brood did not prevent deaths from being keenly felt. The subject was
moving because it was uncomfortably real, and its appearance in fiction
was no accident. Little Nell's deathbed scene was by no means unique.
Faced with the all too frequent occurrence of child death, the Victorians
fell back on sentimentality. They saw children as the embodiment of
beautiful innocence and the essence of simple piety (Fig 111). One

**Figure 111** Unmounted print; Edward Tear, Ipswich (PRO, COPY 1/430)

outcome of this, in photographic terms, was the depiction of children as angels, little souls that had died and gone to heaven. This practice was popular enough by the 1890s for handbooks to be printed, giving instructions for making 'angel pictures' and affixing duck or swan wings. Such photographs were perhaps a shade too intense to have a place in most family albums, but you may come across the next best thing. If depicting a child as an actual angel was a little extreme, it was still possible to portray children as angelic, holding a Bible or Prayer Book, or kneeling unaffectedly at their devotions (Figure 32), perhaps with eyes turned towards heaven.

But even in less healthy times, many little angels avoided becoming the real thing and grew up. In the family album we can see that happening. For both boys and girls, progress to adulthood was punctuated by a number of rites of passage; and although we can rarely be sure whether we are seeing them actually taking place, there may be signs that they have occurred.

For the first few years of their lives, the sexes were dressed alike. Boys wore dresses; and breeching, or the first wearing of a pair of trousers, was a milestone in their lives. There was no fixed age at which this transition took place. It could be as early as three or as old as eight. In practice, the average age of graduation into trousers probably became lower over the years, and in poorer families it may have largely depended on when the family had a pair to pass down that would more or less fit. But the practice

of keeping small boys in dresses, though no longer automatically observed, survived at least until the First World War.

Although photographs were commonly taken to mark the occasion of breeching, they can be hard to identify unless before and after shots were taken on the same occasion. Studio details may suggest that pictures originate from the same session, and consecutive negative numbers or an accompanying sibling whose clothes do not change can provide confirmation. But such certainty is not often to be had. Figure 112, showing Freddie in about 1905, looks as if it could be a breeching picture. It is an amateur photograph, but a white backcloth has been fixed up for what is clearly a significant occasion, and Freddie is demonstrating his skill with braces, socks and shoes. Other pictures in the same album show him in trousers at what seems much the same age, though it is hard to be sure which are the earliest. The most significant clue would appear to be the evident importance of the moment, and it is the one that should probably influence our judgement.

Difficulty can also be experienced with pre-breeching pictures. It is not always easy to decide whether one is looking at a boy or a girl. Readers are invited to form their own conclusions as to the sex of the older child in Figure 100.

Once trousers had been adopted, there was the matter of leg length to

**Figure 112** Trimmed print;
probably from roll film

**Figure 113** Carte de visite;
A. & G. Taylor, London

contend with. Shoe-length trouser legs were coveted as a sign of growing up. The boy in Figure 113 may possibly have only just been breeched. Certainly, at any rate, his trouser legs have a long way to go before manhood. Long trousers remained the ambition of small boys through the first half of the 20th century and beyond.

The other common badge of male adulthood was the watch on a chain. Again, there was no fixed age at which such a treasure might be awarded, though it was likely to come after graduation to long trousers. The middle son in the back row of Figure 103 is probably old enough to have had his watch for a while, but one is aware that its chain is displayed a little more assertively than those of his older brothers, and he does seem a little more conscious of a sense of occasion than they are.

Girls had their milestones, too. As children, they were dressed in short shirts and wore their hair down. As women, their hemline swept the floor and their hair was taken up in one of the prevailing styles of the day. The transition was from child to young adult, for the concept of separate teenage fashions took hold only after the Second World War. A phased advance to maturity came not from the creation of an assertive in-between stage, but from the increasing of skirt length, bit by bit, until the shoes were at last triumphantly hidden. So the girls in Figures 5 and 27 are wearing skirts of around knee length; the older girl in Figure 22 has a hemline at calf height; and the rather grown-up sister in Figure 102 has a longer skirt, although it still stops short of the ground. Since skirt length conveys a message of seniority, we may see that the importance of the older Miss King in Figure 3 is not established by the seating arrangement alone, but also by the difference in the sisters' hemlines.

Hair that has been grown to shoulder length does not lend itself to gradations of up and down. Once caught up and back, its actual arrangement was a matter of adult fashion rather than of staggered progress to adulthood. Whether a bun, say, was worn at the nape of the neck or high on the head depended more on the age of the century than the age of the wearer. So it is clear that the girls in Figures 22 and 102 have yet to be accounted women, whereas the subject of Figure 54 has achieved that status.

The two principles can be seen working together in Figure 114, though we need first to decide how the subjects are related. The family resemblance, created by head shape, forehead, nose and mouth, is strong between the three older sitters, and it is tempting to see the beginnings of family features in the baby. The oldest sitter looks rather too young to be the mother of the two who are next in age, so it seems fair to conclude that the three are sisters. Absence of rings on the hands that hold the baby assures us that the oldest sister is not married and that the baby must be an additional small sibling. A more cynical explanation for the absence of a ring need not detain us. Of course, such things could happen, but we would hardly expect them to be proclaimed in a studio. So, in addition to

**Figure 114** Carte de visite;
W. H. Mason, Croydon

W.H.MASON. PHOTO CROYDON.

the baby, we are looking at three sisters of varying ages. It is hard to tell which of the middle children is older, and so we can't be sure where the standing sister, whose hemline is hidden, fits into the sequence. But we can see that the girl on our left is wearing a calf-length dress, and that both middle children are wearing their hair down. The seniority of the sister holding the baby is marked both by her hair being caught back, probably in a low bun, and by her dress, which is clearly rather longer, and which, if she were standing, would probably reach the floor.

It is easy for us to regard individual photographs as frozen moments of time. Indeed, in a sense, they are. But evidence of children passing through the stages of growing up can also alert us to the passage of time and to the milestones in a young life. There is, too, some justification for thinking about the mood of the subject. When we see a small boy in trousers or a girl with her hair up, we may well be looking at young people who are feeling rather good about themselves.

# 6 Beyond the Family

## Brought in

The family does not, of course, exist in a vacuum. There is a wide world beyond it, and that world is sometimes reflected in its collection of photographs. In fact, there is the possibility of a two-way traffic. Pictures from the outside world may have been brought into the family album, and the same album may contain records of the family's excursions outside its own circle.

As has already been indicated, extraneous portraits were common in Victorian albums. Royalty was in the greatest demand, and pictures of Queen Victoria and the members of her family were hugely popular (Figure 115). But anyone who enjoyed national or local fame exercised some degree of attraction and represented potential earnings for the photographer who could persuade them into the studio. So images of politicians, writers, civic dignitaries and pillars of the church (Figure 18) might all find their way into the home.

Specific events could greatly stimulate the market in such pictures, as the diarist A. J. Munby discovered in 1861, after the death of Prince Albert:

'Crowds round the photograph shops, looking at the few portraits of the Prince which are still unsold. I went into Meclin's to buy one: everyone in the shop was doing the same. They had none left: would put my name down, but could not promise even then. Afterwards I succeeded in getting one – the last the seller had – of the Queen and Prince: giving four shillings for what would have cost but eighteen pence a week ago. Such facts are symbols of the great conviction of his worth & value which the loss of him has suddenly brought to us all.'

Such facts are also evidence that dealing in portraits of the famous could be a very profitable business. The largest retailer of such pictures was Marion & Co., the originators of Figure 18, who have been encountered in an earlier chapter as photographic suppliers. The company acted as agents and publishers, rather than as photographers in their own right, and they did so on a grand scale. In 1862 it was estimated that around 50,000 pictures were handled monthly by the organization's London operation, and the death of Prince Albert prompted sales for them of some 70,000 cartes.

**Figure 115** Carte de visite;
photographer unknown

One of the largest operators involved in taking their own pictures as well as selling them was the London Stereoscopic and Photographic Company. A major presence in the stereoscopic market, the company was also a vigorous competitor in the portrait sector and bought photographs from freelance practitioners to supplement the work of their own staff. It had a highly successful record of attracting celebrities, of whom the Queen's relative by marriage, the Prince of Saxe-Coburg-Gotha (Figure 116) was just one example.

The value of a good picture to such publishers is evident from the prices they were willing to pay. In 1876 the Marion organization spent £185 on a negative of the Prince of Wales, even though the picture had been previously circulated. But this pales into insignificance beside the £1,000 said to have been offered by London Stereoscopic in 1878 for a picture of William Gladstone taking a rest from chopping wood.

A note of warning needs to be sounded, in view of this flourishing portrait business. We should not be misled into assuming that everyone represented in a Victorian family album is actually family. The presence in its pages of the good and the great is no evidence of even the most tenuous blood relationship.

The fascination with celebrity continued well after the Victorian period. Indeed, it has never faded, though the sorts of photograph and the profile

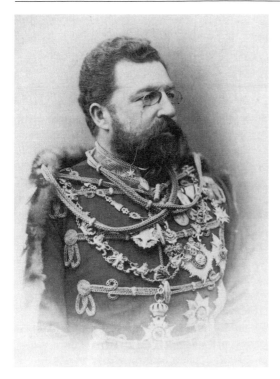

**Figure 116** Unmounted print;
London Stereoscopic & Photographic
Company (PRO, COPY 1/430)

of the average collector have of course changed. In the early years of the
20th century the taste that had once been fed by cartes and cabinet prints
came to be catered for by postcards. A new royal generation was depicted
and, although the range of subjects was still wide, a growing interest in
entertainers became evident. Stars of music hall, musical comedy and
straight theatre were popular subjects, and in due course film actors made
their appearance. The topographical picture also grew in popularity.

If family postcards have survived, they may suggest something of
interests and tastes, showing loved places and admired figures. Photo-
graphs of leading suffragettes, for instance, proved marketable, as did
Women's Social and Political Union badges, hatpins, scarves and other
souvenirs. So the survival of a picture of Mrs Pankhurst or the WSPU brass
band may reflect the sympathies of a family member.

If a card has been through the post, the handwritten message may
confirm that the picture is of some significance. Sometimes we learn more
about the sender than the recipient – as with 'My favourite English actor',
written beneath a portrait of Johnston Forbes-Robertson sent to a Miss
Thorndyke in 1906. On other occasions, though, a shared experience is
referred to. So, a 1904 postcard of actor John Martin Harvey bears the
message 'Reminiscences of the Lyceum'; and in the same year, to a scene
from *The Duchess of Dantzic* has been added 'Do you recognise the officer
with the clanking sword?'.

Less precise in its indication of interests, but rather more common, is the suggestion that the recipient might like to add this picture to his or (more usually) her collection.

## Going out

Members of the family also went out into the wider world, and their photographs may offer evidence of what they did or what they saw. Because such pictures tend to be taken somewhere other than a studio, they more frequently date from the 20th century than from the 19th. Certainly there were photographers who went out and about in Victorian times, but the less cumbersome equipment and processes of later years made photography in uncontrolled conditions much easier for the professionals, while the arrival of the snapshot camera made it possible for amateurs to create their own visual record.

One way in which members of a family might exercise their sense of social responsibility is through participation in groups with a mutual interest or cause, including religious, political and community organizations of one kind or another. Organizations often place an emphasis on hierarchy and ceremony, and so have officers who are formally installed and who may wear special clothes or accessories to denote their rank. Since individuals are likely to feel proud of their appointment or election to a responsible post, they may wish to record their achievement for posterity by being photographed in the trappings of office. Such pictures are not uncommon. A good example is Figure 117, which shows the Mayor and Mayoress of Bolton on the day of their 1897 garden party. He is wearing his chain of office, and she is carrying two bouquets of flowers. Perhaps the smaller one was a chosen accessory and she was presented with the second. It would not require any great flight of fancy to read a sense of pride into the picture.

Although this example was taken out of doors, many were not. Office-holding pictures fell into a category that 19th-century photographers could handle with no great difficulty, for the robes, apron or chain could as well be worn indoors as anywhere else. Consequently, family albums hold their share of studio portraits showing Victorian or Edwardian men dressed to preside over council, association or lodge.

Figure 118, on the other hand, could only have been tackled in the open, for it has to accommodate a banner and horses in addition to a large group of people. This is a gathering of Foresters at Chippenham in 1897. Organizational trappings are much in evidence, and men without some splash of finery are in the minority. Quite apart from the plumed hats and lacy coats of those in full costume, there are stars, neck-ribbons, sashes and tassels on display. It may well be that the bowler hats, too, confer a degree of status. It would appear that some very improbable beards and a cigarette in the mouth of one of the riders were not thought to be an impediment to the dignity of the occasion.

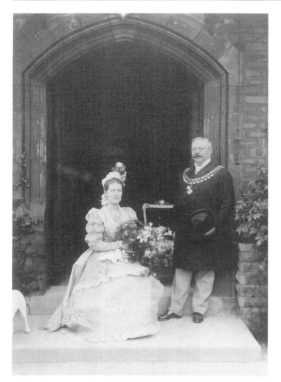

**Figure 117** Unmounted print;
Nathan Kay, Bolton
(PRO, COPY 1/430)

Photographs of outings are also, in a sense, 'public' pictures. Holidays, which tended to be essentially family affairs, have already been touched on. But for many people such a luxury as a week at the coast was not to be envisaged until well into the 20th century. Bank Holidays had been introduced in 1871, but extended breaks could not be considered by the poorer classes until the right to a paid holiday became law in 1938. There were, however, day trips to the sea or countryside, and these were often communal affairs run by or for workforces, social groups or institutions.

Figure 119 appears to show just such a trip starting out from the Warde Arms at Westerham in Kent. The destination is not known, but Brighton is the nearest seaside town. Mr Johnson's brake is closely packed, but, if it is a journey to the coast that is planned, he will not necessarily be taking the party all the way. The intention may be to link up with the London to Brighton railway, which had played a major part in making the town such an enormously popular day-trip resort. The travellers look fairly serious, but the presence of a trombone suggests a determination to be jolly before long. The children – who are not members of the Warde Arms clientele or social group, which would have been saving week by week for the outing – look on with interest.

Excursions were just one kind of leisure activity. Another which may find some coverage in the family photograph collection is sport. Team

**Figure 118** Unmounted print; Frank Reynolds, Chippenham (PRO, COPY 1/431)

pictures were, and still are, popular; and the enduring conventions of such groups were soon established. The organization of players into rows filled the frame, gave a variety of heights, and allowed all the faces to be seen. Senior players were seated on chairs or a bench, with the captain in the middle, flanked by other key performers. Recent trophies were prominently displayed. All of these conventions are observed in Figure 120, which brings together the first and second netball teams of the Accounting and Tabulating Machine Company, winners of the London Business Houses' Netball League in about 1936. But they have not followed the practice common among male teams of folding their arms or placing their hands on their knees. The resting of hands in laps was probably considered more ladylike and certainly looks more comfortable.

Action pictures of sport depend on film that is fast enough for the necessary short exposures; but static moments, if well chosen, could offer a dramatic effect, as demonstrated by W. Berry of Rochdale in Figure 121. According to the handwritten note on the back of the postcard, the event was the 'Ardwick Boys at Display work'. Judging by the mixture of spectators' hats, it occurred shortly after the First World War. The resulting picture is now rather grubby and the white PT kit of the lad at the summit is poorly distinguished against the pale sky, but the unmistakable tension of arrested movement gives the photo a strong impact.

The earliest examples of sporting pictures, however, were likely to be

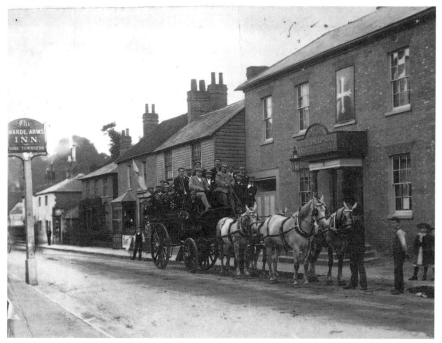

**Figure 119** Unmounted print; Arthur Dean, Westerham (PRO, COPY 1/432)

studio-bound. Usually the athlete appeared in the appropriate kit, holding an item of equipment belonging to the activity in question. Less predictable, though, were the six men who presented themselves at Robinson & Sons' premises in London's Regent Street in 1889 (Figure 122). Messrs Blakelock, Dunning, Webb, Burns, Suffolk and Prichard were pugilists, but they preferred to appear in their buttonholed best rather than stripped for combat. Armed with knowledge of their identity, the viewer may be tempted to speculate on the power of their fists and look for damage to their ears and noses, but nobody approaching this photograph without the necessary additional information would assume it had a sporting theme.

Although for most people a greater proportion of their time was taken up by work than by leisure, work is nevertheless a rather under-recorded subject. In fact photography was over 60 years old before working people began taking pictures of each other; and when they eventually did so, documentary realism was not their usual concern. Nor, in Victorian times, were they inclined to present themselves to the professional photographer in the role of labourer or artisan. Because a visit to the studio was a special occasion, people wanted to look their best and they dressed accordingly. So when the 19th-century camera gives us a glimpse of working life, it tends to be by courtesy of employers and their class.

From the earliest days of photography, well-bred experimenters and

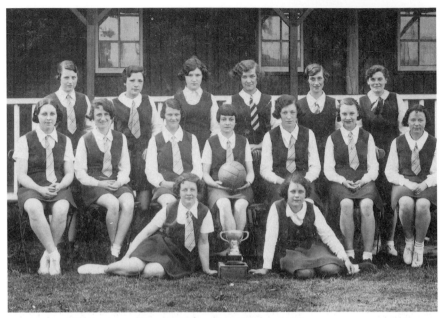

**Figure 120** Postcard; C. H. Price, Croydon

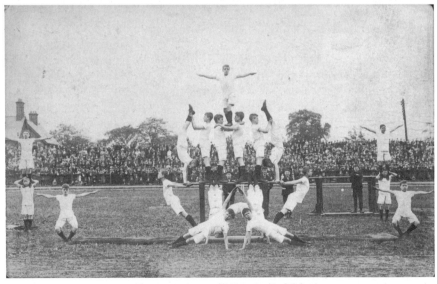

**Figure 121** Postcard; W. Berry, Rochdale

country-house amateurs showed an interest in taking pictures of the humbler sort, as well as of friends and relations. Fox Talbot captured a selection of those employed on his Lacock Abbey estate, and the work of David Hill and Robert Adamson embraced leaders of Edinburgh society, soldiers garrisoned at the castle, and the fisher folk of Newhaven. In the

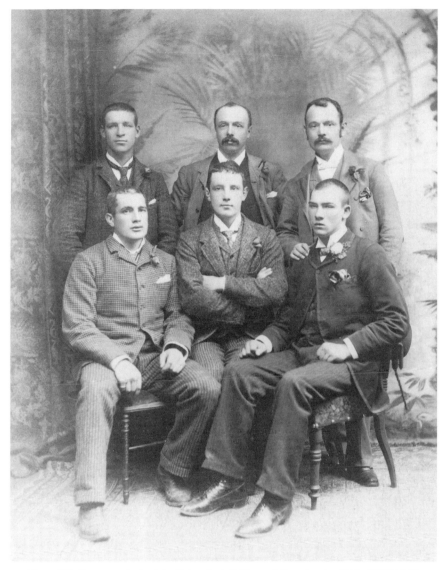

**Figure 122** Unmounted print; John Bolton for J. Robinson & Sons, London (PRO, COPY 1/396)

1860s and 1870s, fascinated by labouring women, A. J. Munby persuaded collier girls and dust wenches to enter studios in their grimy working clothes and submit themselves to the camera's scrutiny. At much the same time, Mrs Percy Wyndham, who had married into Lord Leconfield's family in 1860, was accumulating and annotating an extensive collection of portraits of the servants at Petworth House. Bailiff, groom, French cook, nurse, shepherd, huntsman and clerk of the works are just some of those whose images she preserved, with comments varying from the affectionate

('*Dear* old Bowler'), through the respectful ('A Baptist, died at a great age. An honest able man.') and the frank ('Cannot remember his name.').

So the working people who predominate in early pictures are domestic and estate staff, plus a scattering of those who appealed to photographers with specialized pictorial tastes or social interests. But even in the 20th century, work-related pictures were fairly uncommon. Once people started taking their own snapshots, they were concerned to show themselves having fun, going on outings or attending celebrations. Work was something to forget about when the day or week was over; and, in fact, it has never become a standard subject for the average photographer.

This is why the postcard appearing as Figure 123 is valued, despite its battered condition. It shows a group of labourers, probably mainly turbine cleaners, who worked for a local power company shortly before 1914. The older man and the youth sitting beside him are father and son. The men are shown during a break, which may account for the generally cheerful mood as well as the bottle on the ground. Although some visual indication of their work would have been interesting for us today, their working clothes give a sense of authenticity that sets the picture apart.

From the same sector of industry, but a few years later, comes Figure 124. It, too, has lost a corner, and it bears stains which show that it has at some time been fixed in place with adhesive tape. In the bottom margin has been written 'Power station 1920', and a note on the back identifies 'Dad in Fan Engine Place / 2nd from right. about 1921'. This workplace is clearly one in which some pride can be taken. The control panel on the right looks appropriately complicated, the space is well-lit and high-

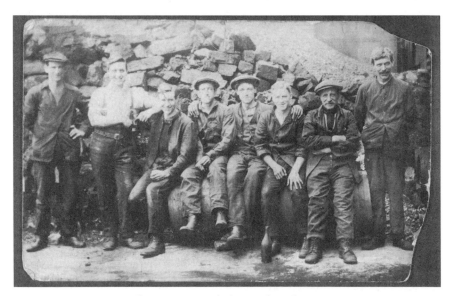

**Figure 123** Postcard; photographer unknown

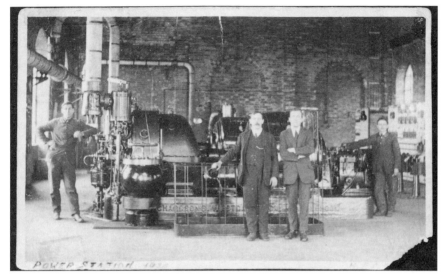

**Figure 124** Postcard; photographer unknown

ceilinged, there is a multiplicity of gleaming surfaces, and it is an area where suits may be safely worn.

In addition to their work and leisure, members of a family sometimes become spectators of or participants in public events – including war.

The earliest war pictures date from the 1855 visit to the Crimea of Roger Fenton, who the previous year had taken the Queen's belated wedding photos (see page 91). The technology of photography was not yet capable of action shots, and his record is generally of harbour and campsite scenes, with groups of officers and men in fairly relaxed mood. The results tend, inevitably, towards the bland, though his shot of the Valley of Death has some power to disturb. It shows the scene of the charge of the Light Brigade, empty and littered with cannon balls. The events that had occurred there are left to the imagination, and the absence of people serves to emphasize the sense of desolation. It has been argued that people were not yet ready for anything more immediately harrowing. But, ready or not, they were faced with it only a year later, when Queen Victoria met a group of the war's wounded at Chatham and an anonymous photographer took a picture of a group of amputees she had seen. A very few years later, the American Civil War saw a new immediacy brought to war photography, when, from 1861, Matthew Brady headed a team of documentary photographers who did not flinch from showing battlefield casualties.

The first war to coincide, in part at least, with the age of popular photography was the Second Boer War (1899–1902). In the event, however, its images proved to be more professional than amateur. Some intriguing pictures survive from this time, and two examples are chosen for their qualities of family appeal.

Figure 125, by Charles St John Vaughan of Bradford, dates from 1900. Entitled 'Dinner Time', it shows soldiers eating a meal in their barracks. In any large group, there was always a high risk that somebody would move and blur the picture, but for that somebody to be a central foreground figure was especially bad luck. It is, nevertheless, an enjoyably detailed picture, with some vigorous eating, some ad hoc furniture, and an interesting assortment of hats distributed on heads and racks. The blurred figure appears to be stretching to claim his share of bread, though the best part of a loaf is available just to his left. The soldier on the extreme right has put his bread into the bowl, which he appears to prefer to the plates used by everyone else.

Figure 126, taken in 1901 by William Osborne for the business of William Wallace Jones, records the return to Builth Wells of volunteers who had served at the front. The war would continue into the next year, but this was a time for celebration as far as inhabitants and homecomers were concerned. Flags, spectators at windows and a band in the foreground all add to the sense of excitement. There is such a crowd that small children are being held on shoulders, spectators are perched precariously on the parapet to gain a better view, and the soldiers themselves seem almost lost among their admirers as they squeeze across the bridge. Among the civilian fashions to be seen are the large collars worn in Harrovian fashion by some of the boys. (At Eton, to which this style is often attributed, the large collars were kept inside the jacket.)

**Figure 125** Unmounted print; Charles St John Vaughan, Bradford (PRO, COPY 1/445)

**Figure 126** Unmounted print; William Osborne for William Jones, Builth Wells (PRO, COPY 1/450)

Except where copies of professional pictures were purchased, family collections are likely to be rather more modest in their reflection of war. They are, mercifully, more likely to reflect the spirit of Fenton than of Brady, and until the Second World War may show more uniforms being worn at home (Figures 13 and 104) than in the field. In Victorian times, certainly, a visit to the studio was the obvious way of creating a visual memory of a military career. Then, when the First World War began, professionals did brisk business in making portraits of the young men in uniform who were off to fight for King and Country (Figure 127). As mentioned earlier, despite regulations many of the men took a camera with them. However, this is less evident from family snapshots that have survived than from the recorded rise in sales of the Kodak Vest Pocket Camera.

So in family albums it is the Second World War that is more likely to be represented by amateur pictures, and what we tend to see is journeys to the war zone and interludes between battles. The average serviceman made no claims to be a photojournalist and, in any case, during times of action was rather too busy to be thinking about using a camera. But in the pauses, especially once victory seemed a possibility, he had the opportunity to

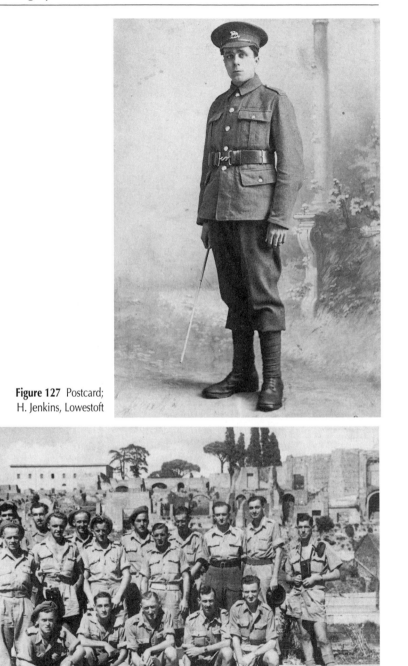

**Figure 127**  Postcard;
H. Jenkins, Lowestoft

**Figure 128**  Roll-film print; amateur photographer

photograph the mates alongside whom he had fought and to notice the exotic locations in which nothing less than warfare could ever have placed him. Figure 128 shows a number of soldiers in Rome in August 1945, and it will be noticed that they have chosen an agreeably picturesque background for their photo. This would appear to be one of those occasions when individuals take it in turns to detach themselves from the group in order to take a shot of their own. Two of the men standing are holding cameras, and the central squatting figure looks as if he, too, has a camera case slung across his chest.

War was not, however, the only outside event that touched families, and all manner of public occasions, both local and national, may be discovered among their photographs. Coronations, jubilees, royal visits and the onset of peace were all marked by celebrations; and the accompanying crowds, processions, public decorations and street parties were all recorded on plate or film. If no member of the family possessed a camera, it was always possible to buy one of the many postcards that were published. In fact, the habit of turning to professionals for pictures of public events still survives in the practice of buying copies of local-press photographs.

There was always the chance, though, that simply by having a camera to hand the amateur would find a chance to record a moment of significance. So when, in August 1931, an unknown amateur photographer on the promenade at Bexhill saw an airship in the distance, he or she set to work with the camera (Figure 129). The airship proved to be the *Graf Zeppelin* (Figure 130), which was enjoying its brief period of fame. In 1928 it had flown both ways across the Atlantic, and the following year it had circumnavigated the globe. It was, therefore, an object of some considerable interest. But already doubts were beginning to be voiced about this form of travel, for in 1930 the British *R101* had crashed on its maiden flight. The decisive moment leading to the abandonment of

**Figure 129** Roll-film print; amateur photographer

**Figure 130** Roll-film print;
amateur photographer

transatlantic airship travel eventually came in 1937 with the explosion of the *Hindenburg*, another of the airships built by the Zeppelin company. But excitement, rather than apprehension, is likely to have been the mood of that holidaymaker who seized the opportunity to record for the family album an important stage in the history of flight.

What seems important may, however, change in retrospect. It is quite probable that the photographer preferred Figure 130, with the airship virtually overhead and its name quite discernible. What would not have been apparent then is that to future generations Figure 129, with its man in a patterned sleeveless pullover and its changing tents on the beach, would convey a sense of history no less eloquently than the *Graf Zeppelin* itself.

# 7 Preserving and Collecting Old Photographs

## Signs of mortality

If old photographs begin to look their age, it is hardly surprising. More remarkable is the fact that so many of them have lasted so well and so much longer than the humans they record – for, at their simplest, they are no more than flimsy scraps of paper or fragile pieces of glass.

In fact, of course, they are more complicated than such a description suggests, though no less vulnerable on that account. A photograph is normally made up of three layers, of which the paper, glass or metal is just the basic support. Then there is the image-producing layer of light-sensitive chemicals, which may include fine particles of silver or platinum, and this is suspended in a transparent binding layer, consisting of a substance such as albumen, collodion or gelatin. This amounts to a complex recipe, and the ingredients are capable, separately or in combination, of behaving in a variety of ways. They can rust, tarnish, become brittle, absorb moisture, discolour and fade, and they are quite capable of doing more than one of these things at a time. In addition, the materials used for mounting, framing or adding surface colour and coating may add to the ways in which the original image is affected. Deterioration is therefore not to be wondered at.

There is even some consolation to be drawn from the ageing of photographs, since the ways in which they deteriorate can sometimes help in the business of identifying the process and so dating the artefact. For instance, as has already been noted, the fine scratches to which the delicate metal surface of the daguerreotype is subject may serve to banish doubts about the kind of photograph that is being looked at. Ambrotypes deteriorate in very characteristic ways, too. With an ambrotype, moisture can seep between the layers of the cased package and promote mould or cause ring marks, and the backing can crack and flake away. A large flake of black varnish has peeled away from the top of Figure 44 without detracting from the portrait's appeal. The photograph shown as Figure 131, however, has fared rather worse, for the flaking is more extensive and the varnish seems to have taken the photographic emulsion with it. That the picture is an ambrotype is proved by the way it has responded to the passage of time.

**Figure 131** Ambrotype;
photographer unknown

But such proof is poor compensation for the effects of age, and there is something rather depressing about badly deteriorating photographs (for which reason this chapter is only sparsely illustrated). It therefore makes sense to understand the threats that photographs face, since we may have a better chance of protecting them for longer if we know their enemies.

The first of these is light. It creates their images by its action on a photosensitive surface, and by its action those images can be erased. Ironically, many modern photographs are more susceptible to fading than their predecessors, for light has a particularly harsh way with colour. But black-and-white or monochrome images are also at risk from exposure to strong light, which not only causes fading but may make paper brittle and encourage the yellowing of highlights. Whilst the sun is the main danger, artificial light – especially fluorescent light – also takes its toll.

Humidity also poses threats to old pictures. High humidity can lead to the growth of moulds, and it may also, in combination with other factors, result in fading. Low humidity, on the other hand, can dry out the paper base of a picture and cause it to curl.

Then there is the question of temperature. Reasonably cool conditions are best; and marked fluctuation is best avoided, for the separate layers of a photograph may expand and contract at different rates as the temperature rises and falls. High temperatures can compound the dangers of high humidity and may accelerate the development of problems that arise from other causes.

Damage can also be inflicted by pollution and contaminants. Some of these may come from outside. Most monochrome images have silver particles in the light-sensitive layer, and these respond to certain chemicals in just the way any other silver might. Sulphur, ozone and peroxides can all cause tarnishing, and contact with them is best avoided. That may seem far enough into the realm of chemistry to be beyond amateur considerations, until we realize that sulphur is contained in such everyday materials as rubber and leather. The fumes of fresh paint and of some cleaning products also present a danger to photographs; and the by-products of live fires can cause problems, too. Dust is abrasive, and the oils and salts exuded by human skin mean that even we are a possible threat to the pictures we value so highly.

Common storage materials present their own difficulties. Wood contains lignin, a cell-stiffening substance that has the potential to contaminate, especially if the wood is new. Since much paper and cardboard is made from wood, albums and boxes may be as much of a threat as chests and cabinets. The methods used to hold pictures in place also give cause for concern, and many of us already have cause to regret our earlier use of sticky tape, 'magnetic' albums and other fastening materials. Adhesives have a range of unpleasant properties: they may stain, they may soak through from the back of a photograph to the front, and they may attract and retain dirt.

The various kinds of plastic that are frequently used in albums, storage envelopes and display books also give rise to problems. PVC can be particularly harmful, for the plasticizers used in the production process may migrate to the surfaces the material touches, producing acidic and solvent vapours. Cellulose acetates, if plasticized, can have a similar effect. Pure polythene and pure polypropylene are chemically inert, though the rather muted transparency of polythene may make it an unattractive choice for the storage or display of photographs. Polyester seems to be the safest of all plastic options and is a common archival choice. For the lay person, however, the difficulty lies not just in knowing which plastics to avoid but also in knowing which plastic is which.

Pollution from outside is not, however, the whole story. Other forms of contamination lurk within the layers of the photograph itself. The lignin that may be present in an album page or an envelope may also be in a picture's paper base or card mount. Brown spots, or 'foxing', are blemishes as common on old photographs (Figure 132) as on the pages of old books, and these can derive from impurities in paper or card. But they can also be the result of rusting specks of metal in the photosensitive layer. Another cause of deterioration from within is imperfect fixing of the print. This or the relatively sparing use of chloride in the preparation of printing papers in the 1880s and 1890s is often responsible for fading, and can even account for degradation of the image in pictures that have been kept in albums and had only brief, infrequent exposure to light.

**Figure 132** Carte de visite;
Joseph Simpson, Tunstall

J. SIMPSON,                    TUNSTALL

Gelatin, used in the binding layer of many photographs, is involved in a variety of problems. In damp conditions it is a nutrient for mould, which may show itself in the form of pink or purplish stains on a print. Gelatin can also absorb moisture which, in its turn, affects the silver content of the photosensitive layer, causing a hazy, grape-like bloom that is especially noticeable in the darker areas of an image. Finally, gelatin is a food much loved by silverfish. Since gelatin featured in several processes used for printing early roll-film pictures as well as in the albumen printing process, many photographs are vulnerable to its side effects.

There remains one other major cause of deterioration in old photographs, and that is simple wear and tear. Many family pictures have been much handled in their long lives. They may have been thrown together in boxes, pored over by successive generations, or carried around for long periods in pockets or handbags. Some will have been given to children to while away a rainy day. Damage can result from frequent handling, and it can range from creases and lost corners (Figure 123) to what look suspiciously like tooth marks (Figure 133).

Even pictures that have spent their lives in albums may have incurred a degree of wear and tear, as witness Figure 134. This cabinet print has spent over a century in a custom-designed album with precut apertures. Over the

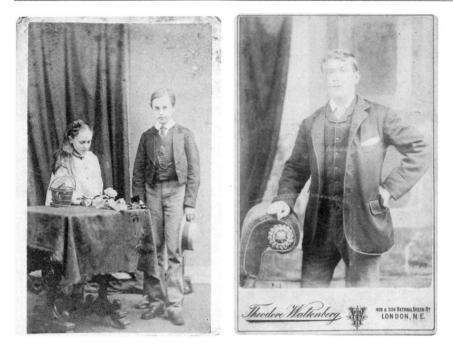

**Figure 133** Carte de visite;
Burgess & Grimwood, Norwich

**Figure 134** Cabinet print;
Theodore Waltenberg, London

years, the edges of the carte de visite apertures on the opposite page have pressed against the portrait and caused abrasions. So a pale line runs up the man's left leg, turns at a right angle, and curves across his right cuff. A less prominent mark has been caused by the carte aperture in the upper half of the facing page, and faint parallel lines can be made out cutting across the left shoulder and below the white handkerchief. These correspond to the bottom edge of the offending aperture and the slit just below it, through which the carte was slid up and into its place. Abrasion from the side edge of the aperture can also be distinguished, passing vertically between the right eye and right ear. Such album scars are not uncommon, and Figure 98 provides a further example.

When all the possible causes of image degradation are taken into account, it seems a wonder that so many old photographs have survived so well. In spite of everything, they can prove remarkably resilient. With a little thoughtful help, there is no reason why they should not last longer still.

## Being a good ancestor

The pictures in our possession are being looked after for our descendants as well as for ourselves, and any pains we take serve both self-interest and posterity. But it is not always easy to decide just what measures should be

adopted. The storing of photographs in ideal conditions can be a costly business, and our own financial resources may dictate some compromise. Nevertheless, if we are aware of what ought to be done, we are then in a position to make decisions about how far we are able, or willing, to go towards actually doing it.

Careful handling, at least, involves little or no expense. It costs nothing to avoid touching the print surface and to hold prints and negatives by the edges, and it is common sense to keep food and drink away from the work area. If minimal outlay can be contemplated, white cotton gloves can be bought very cheaply from a chemist's shop. They are safer than surgical gloves (for humans as well as photographs), can be easily washed, and really are not inconvenient to use.

Storage involves trickier decisions. The first consideration is the room itself. Attics, basements and outbuildings can be damp and dusty. Garages may present the same disadvantages, but with the addition of fumes. All are unsuitable. The temperature variations and steam associated with kitchens and bathrooms rule them out immediately. The living areas of modern houses do tend to be kept rather warm, but are nevertheless likely to provide the most suitable conditions. A bedroom or study may be less liable to wide swings of temperature than a sitting room or dining room. A dry, fairly cool cupboard may well prove useful. Proximity to fires, radiators and hot or cold water pipes is clearly undesirable.

When storage units are considered, lignin-rich new wooden chests or cabinets are to be shunned. Older wooden furniture may have passed its actively dangerous period; and polypropylene containers may be worth considering. Metal cabinets, enamelled rather than painted, are generally reckoned to be safe; and because they are standard items of office furniture, they have the added advantage of being readily available at a reasonably low cost.

The hardest decisions, because potentially the most expensive, arise when the smaller storage items are considered. A good room and a chemically inert cabinet may have been settled on, but there is still the need to contain and organize at the level of small batches and individual pictures. Choices have to be made about such items as boxes, envelopes or other enclosures, and albums. Whatever is chosen needs to protect the pictures from dust and light and has to lend itself to some kind of ordering or system, so that the collection can be referred to easily. But it must also be likely to do no long-term harm, and that places a large question mark over wood-pulp paper and card and over some kinds of plastic. Archival-quality supplies are the obvious answer, but they have their price and purchasing decisions may be influenced as much by budget as by ideals.

It is possible to buy boxes, albums and storage sheets made of materials which are currently considered safe. Archival suppliers offer products made of acid-free and lignin-free paper and board and of high-quality inert polypropylene and polyester. If glue is used in their manufacture, it is

carefully chosen, too. There can be no doubt that the use of such items represents the best chance of preserving photographs for as long as possible in the best possible condition. If they are acceptable to the professional, they should certainly satisfy the amateur. Unfortunately, however, they tend to be rather costly.

If the perfectly stored home archive is out of the question, there may be compromises that can be made. Some family photographs may, for example, be even more treasured than others, and expenditure on part rather than all of the collection may be a reasonable solution. But, setting aside financial questions, there are a number of practical details that are well worth considering.

If photographs are stored flat, the weight of the pile will prevent them from curling. Should upright storage be preferred, as in the pockets of a filing cabinet or in albums placed side by side on a shelf, it makes sense to ensure that the material is closely enough packed for gentle side pressure to perform the flattening function that is otherwise achieved by gravity. If glass negatives are being stored, then a different set of priorities comes into force, as the lower examples in a stack could crack under its weight.

Whether kept flat or upright, in boxes, folders, envelopes or albums, photographs should never be placed face to face. It is possible for surfaces to stick to each other, so allowing images to touch each other can be a way of ensuring that you ruin two photographs at a time. Separate enclosures, interleaving in albums, and even simple face-to-back storage are all ways of avoiding such disasters. It may be noticed that many pictures have survived face to face in Victorian albums without benefit of interleaving, but the system of precut apertures has contrived some protection for them. The photographs in those albums were slipped between the outer paper layers of a stout-board page that was thick enough to accommodate card-mounted pictures. The paper edges of the aperture provided a kind of matt or frame which acted as a buffer between the picture's surface and the opposite page. It will be noticed that when album scars have been formed (Figures 98 and 134), it is aperture edges rather than photographs that have caused the damage.

Turning to the somewhat vexed world of plastics, it is clear that PVC should be avoided. The problem, though, lies in recognizing it. Those confident of their sense of smell may discern an acid aroma. Others, who may make up the majority, will settle for caution and will be reassured only by explicit labelling. The difficulty here, though, is that labels rarely make clear the composition of high-street storage and stationery products, and it may be only the more expensive or specialist suppliers who can provide the necessary assurances about their goods.

Then there is the topic of albums. Whilst it is desirable to store photographs away from light, the family historian will want to be able to retrieve them easily and look at them conveniently displayed. This is the great attraction of albums. They enfold their contents in darkness until

wanted, and then reveal them logically arrayed and annotated. But the choice of album requires some thought.

Archival-quality albums are, of course, ideal, and those with paper pages tend to be more flexible than those with polyester or polypropylene pockets for slipping pictures into. Preformed pockets in effect make their own decisions about picture size and portrait or landscape format, before any photograph is actually put into them. The use of variously configured pages and loose-leaf binders helps to overcome this problem to a degree, but in a paper-paged album each new sheet allows a fresh approach to the use of space.

If considerations of cost encourage you to look at high-street options, it is necessary to be cautious about albums with so-called 'magnetic' self-adhesive leaves. These were on the market for a very few years before complaints about staining were heard. Doubtless the bitterest complaints arose from the use of the cheapest versions, and improvements may well have been made. But I have encountered albums which rely on both the stickiness of coated board and the clinging qualities of unspecified plastic. In such cases the basic argument is simple and compelling. Since unidentified adhesives and plastics can each pose potential threats to photographs, it seems unwise to adopt a storage system that brings pictures into direct contact with both of these substances at the same time.

There are, fortunately, other ways of positioning photographs in an album. Plastic pages tend to be already divided into more or less convenient pockets. With paper pages, any fixing method that allows an adhesive to touch either the back or front of a picture should be avoided. Glue, tape and 'invisible' mounts (sticky on both sides) are therefore not to be recommended. Precut slots for tucking corners into were popular in the first half of the 20th century, but they became rarer as print sizes became more varied and less predictable. Photo corners at least adhere only to the album page, and their plastic fronts touch only the tips of the print.

Consideration has so far been directed towards the provision of new accommodation for family photographs, but many of us are lucky enough to have inherited a collection already housed in an old album. If the pictures are obviously deteriorating or the album itself is disintegrating, then remedial action is clearly called for. But if there is no apparent cause for immediate concern, the case for keeping things as they are is worth considering. Victorian paper and board were no more free of lignin than our own, but it is probable that any damage will already have been done and that the album, after more than a century, has become a fairly inoffensive environment for its contents. An old family album is certainly an attractive heirloom in itself, and even if it lacks annotation the order of pictures within it may have its own tale to tell. Sentiment will argue for its preservation, and reason will provide at least some support.

However the collection is stored, it needs to be documented. The disappointment we feel when discovering how little detail accompanies the

pictures we have inherited should persuade us to make matters easier for future generations, identifying subjects and assigning approximate dates wherever possible. But even that important activity can be the cause of damage if care is not taken.

If possible, the enclosure or album page, rather than the picture itself, should bear the information. But if it does seem necessary to write on the photograph, it is the back that should bear the inscription. Adhesive labels are taboo, and a pen should never be used. Ball points are liable to gouge the surface, leaving an impression that shows on the front of a print, and ink can bleed into the fabric of the paper or card. The answer is not simply pencil, but a very soft one. In practice, this means a 6B pencil – which leaves a coarse line and needs constant resharpening, but will be more easily erased. The use of an identification code referring to fuller information in separate notes will keep the actual writing to a minimum. The basic principle is to add nothing to the artefact that cannot be removed readily and without damage. Incidentally, pencil is best for marking enclosures, too, since ink should be kept as far away from photographs as from any other old and valuable documents.

One documentation idea that may be worth considering involves the use of photocopies. Modern machines do a reasonable job of reproducing pictures, at least well enough to show which copy comes from which original. The necessary identification and supporting information can then be written on the same page, next to the image. The obvious objection is that during copying the photograph is subjected briefly to very bright light. But the resulting illustrated notes may subsequently be used for reference, thereby reducing the number of future occasions when the picture will be handled and exposed to light.

There is also an important place in the conservation armoury for photographic copying, for this has its uses when it comes to display, 'first aid' and enlarging the family collection.

Tempting though it may be to have old family portraits on show, that involves prolonged exposure to light. Use of a wall or shelf that is out of the sun might delay fading, though in selecting a suitable spot it is important to bear in mind that the sun's rays come in at different angles over the course of a year, as well as over the course of a day. Frames fitted with ultraviolet filtering may also reduce the dangers. But a much better solution is to make, or have made, a copy of the original that can be proudly shown off and can fade when it will, whilst the original is kept safely in the darkness of an envelope, box or closed album.

Damaged or deteriorating pictures can be a source of concern, and attempts at cleaning or repair can be hazardous. A soft brush may be applied to the face of a picture, and a soft eraser might be used to clean up the back of a grubby mount. It is said that ink marking can be removed from an image with metal-polish wadding, followed by buffing with cotton wool. Although it is sometimes suggested that this might be risked in the

case of modern plastic-based photographic 'papers', such a practice goes against every instinct that relates to caring for pictures. The safest conclusion is that 'first aid' – and any other attempts at restoration or repair – are best left to professionals. It is, however, possible to make a copy of a vulnerable photograph before it deteriorates further. In that way the image will survive in the best state possible, however much the original decays. It is worth pointing out, too, that copying can now be done by computer, as well as by camera, and once the picture has been scanned in, it can be manipulated to disguise scars and improve quality. Even traditional photographic copies, because they are exposed to make the most of contrasts, can to some extent improve on the original. Digital copies can go further still.

Finally, there is the matter of building up a fuller set of family pictures. In general, a collection of photographs can be augmented by visiting antique shops, collectors' fairs and, for the devotee, specialist auctions. Individual cartes and cabinet prints can still be found at very modest prices, though cased pictures and full albums cost rather more. But the kind of collecting envisaged by the reader is more likely to be the expansion of the family archive, and this is another area in which photographic copying can be of help. Other members of the family may well have interesting pictures that they have no wish to relinquish but would be prepared to lend for copying. Indeed, if they are reluctant to let them out of their possession even temporarily, it may be possible, with a single-lens reflex camera and close-up filters, to make at least passable copies on the spot. Offering to exchange copies from one collection with copies from another might be a graceful gesture, and it could help to convince doubters of the attractions of the idea.

# 8 Case Studies

## The 1860s

In this last chapter, theory is put into practice by focusing on a selection of pictures spanning some 80 years and examining the ways in which they can be dated and interpreted.

Representing the 1860s are Figures 135 and 136. Both are cartes de visite, and both have the square-cornered mounts with simple trade-plate backs that suggest the 1860s. But they appear to date from opposite ends of the decade.

Figure 135 has a number of small greyish-brown stains on both mount and print, which probably arise from impurities in the paper or, since both are affected, the card. It shows the full-length seated figure which is characteristic of the time. The frock-coated subject appears quite at ease, as suggested by his crossed legs and occupied but relaxed hands. His gloves are draped on the top hat beside him; and that hat is quite high-crowned, as was the fashion in the 1850s. The squarish toes of his shoes also hint at an early date, as more pointed toes became usual during the 1860s.

Information about the photographer confirms one's inclination to place this portrait no later than the first few years of the decade. His name and address, printed in a ribbon design on the back, identify him as Robert Burrows of St Stephen's Church Yard, Ipswich. A look at Suffolk trade directories of the time proves helpful. In 1858, the year in which cartes were introduced to England, an R. Burrows is shown as practising photography at the Church Yard address, while an R. Burrows junior has a studio in St Peter's Street. No Burrows appears as a photographer in the next directory, which dates from 1864, or in any subsequent volumes. This leads to the conclusion that Figure 135 must belong to the early 1860s or even the late 1850s.

Nevertheless, it is a photograph that contains seeds of the future – for it reveals that Robert Burrows, whilst not practising for long, ran a forward-looking business. The open-air backcloth, the rustic seat and the use of vignetting are all well ahead of studio fashion. A second piece of studio furniture is partly glimpsed at the right-hand edge of the image, and it seems a pity that the vignetting should deny us a better view.

In Figure 136, it is the taste of the subjects rather than of the photographer which points to times ahead. The studio setting, with its

**Figure 135** Carte de visite;
Robert Burrows, Ipswich

curtains, plinth and interior-to-exterior backcloth, belongs to the later part
of the 1860s. The mount's trade-plate back, naming Sidney of West
Hartlepool, has its lettering set on the diagonal. As innovative design goes,
this may be fairly cautious, but the angle also suggests the decade's second
half.

Another indication of the 1860s comes from the skirt of the woman on
our right, which seems to be supported from inside, in fairly restrained
crinoline fashion. There is significance, too, in the beards of the two
central men, neither of whom has opted for the full effect. The tendency
during this decade was to stop short of complete facial cover, and both of
these men have shaved their upper lip. The older man has also kept his
lower lip and an expanse of chin free of hair.

But there are signs of the coming fashions in the dress of the younger
women. The seated figure at the front is in some ways confusing (her face
is hidden and her pose looks rather uncomfortable), and yet there is an
indication of the 1870s in the frills at her hemline. The standing women
both wear small hats that are tilted forward (to accommodate the chignon
hairstyle) in a way that started to feature on fashion plates from around
1868. They also have the beginnings of the fussiness about the throat that
was characteristic of 1870s styles. Although they belong to the same
decade as the studio, they are just about ready to leave it behind.

**Figure 136** Carte de visite; Sidney, West Hartlepool

Some attention to the grouping is also deserved. It looks as if two studio settings have had to be used in order to accommodate a large and, at that time, difficult number of people. A single sitter might have been posed either by the plinth and curtain or before the curtain and backcloth. But seven subjects have been fitted in, and they have been arranged in a very tight composition on three different levels. A closeness is suggested by three hands resting on three shoulders, and the foreground figures on low stools may be gazing at each other, though the veil makes it hard to be sure. The young woman on the left at the back seems to be looking quite fondly at the man next to her, and his eyes seem to be turned towards her. Nevertheless, the grouping lacks cohesion, for the second standing woman is looking away from the group, and the older man is staring sternly at the camera. But it is the woman at the front who dominates the picture, and her pale dress and veil are in sharp contrast to the generally dark colours worn by her companions. It's a very striking image and, when the grouping is examined, it is also a little disconcerting.

## The 1870s

Two more cartes de visite are selected to represent the 1870s. The first of these, Figure 137, shows another group, but of a much more routine kind.

**Figure 137** Carte de visite;
Joseph Simpson, Tunstall

The father, seated, and the mother, at his right shoulder, are shown with nine children, and family resemblances are not hard to find. Again, the group is organized on three levels and is rather too large to be accommodated within one defined studio area. A coherence is achieved by a mixture of touching and leaning, and all, except one uninterested small daughter, are looking at the camera. Costume details belonging to the 1870s are abundant: both the bows and jabots at the women's throats and the frills at their shoulders and at different levels of their skirts are absolutely of the time; the taste for colour contrasts can be noted on two of the girls' dresses; and the mother can be seen to be wearing a bustle, which is also likely to be a feature of the dresses of her older daughters. The men are not marked out by finery, and the father has not succumbed to the growing practice of wearing a complete beard, but the tightness of the jackets worn by both the central and, particularly, the sitting son is typical of the age.

The picture offers some opportunity for social comment. Students of the rites of passage will recognize the suitably short skirts and trousers of the three youngest members of the family, while those alert to gender issues will notice that it is the eldest son, rather than the mother, who has the second chair.

The carte itself is old-fashioned enough to have squared corners, but the design on the reverse takes up the whole space and incorporates swirling leaf patterns, a camera, an artist's palette and the motto 'Excelsior'. The photographer, named on both front and back, is Joseph Simpson of Sneyd Street, Tunstall, and his work has survived well. When caught in the right light, some small patches of the bloom sometimes associated with gelatin are discernible in the darker areas at the top and on the right-hand edge, although they are fairly insignificant. There is no apparent sign of fading but, as is usual with albumen prints, the highlights have yellowed over the years.

Fading and yellowing are not mutually dependent, but they do often occur together, as appears to be the case with Figure 138. The fading may not, however, be as marked as it first seems. The darkness that remains in eyes, lips and necklace suggests that the soft middle tones of the hair and sleeves are much as they should be, and that even in its original state the picture had a certain muted delicacy.

What the portrait shows, and shows very well, is the one major feature of women's fashion in the 1870s that Figure 137 lacks. Highly elaborate hairstyles were popular for much of the decade, and the sitter in this picture is following the vogue for hair pulled clear of the ears and built up on the head in coils and tresses. However, it may not have been all her own. It was the custom to use artificial hair to bulk out the natural growth and help build an impressive edifice. There was profit to be had in making false hair, and it was said that at the height of the fashion one company was measuring its weekly output in tons.

Like Figure 135, Figure 138 is a vignette that dates from well before the days when the effect became widespread. Yet the mount is very simple for its time, for nothing is printed on the back. There is simply a pencilled serial number and, handwritten in ink, the message 'Yours sincerely Anna Maria Shore'. But the photographer is identified on the front of the mount, as Henri Claudet of 107 Regent Street. Beneath this, in the same small and modest lettering, is printed 'By appointment to Her Majesty'.

The royal warrant had, in fact, been earned by Henri's father, Antoine, who had been taught the daguerreotype process by Daguerre himself and who had opened London's second professional studio in 1841. He moved to premises in King William Street in the late 1840s, before operating for a number of years at the Regent Street address. It was while there, in July 1855, that he was appointed 'Stereoscopic Photographist to Her Majesty'.

Henri succeeded to the business at the end of the 1860s, and continued working under his own name until the early 1880s, when he went into brief partnership with George Gerrard. The royal warrant that he boasted of may not have been held in his own right, but he was part of a tradition dating back to the very beginnings of photography and, on the evidence of this portrait at least, he worked with a delicate touch.

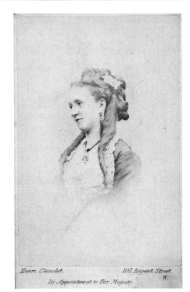

**Figure 138** Carte de visite;
Henri Claudet, London

## The 1880s

Each example shows a standing female subject, framed at less than full-length against a romantic wooded backcloth that is characteristic of the decade. Both women display a high 1880s bustle as part of a dark narrow-sleeved, high-necked outfit which, compared to the excesses of the 1870s, is relatively simple and sober. Both have hair that keeps close to the shape of the head and forms a fringe at the front. But there are differences. The younger woman wears a dress with a piecrust collar. The older is in a two-piece costume, which is shaped at the back to allow for the jutting-out of the skirt.

Figure 139 is a cabinet print that has been slightly trimmed to fit an album space more easily, and the edges of the page's aperture have worn a faint scar just inside the edges of the image. Deterioration is evident in the pale spots clearly visible on the darker parts of the surface. The mount is cream-coloured, with the red printing and pictorial back that are typical of the 1880s. The photographer, John Hart, operated from 179 and 181 City Road. Pritchard's *Directory of London Photographers* shows that Hart had opened a studio at number 179 by 1886 and had expanded into 181 by 1889. If, as this suggests, the photograph dates from the end of the 1880s, then the bustle worn by the subject was, by that time, just a little out of fashion.

The woman holds a spray of flowers on a fan (both traditional accessories of femininity). She gazes straight at the camera, yet seems rather lacking in confidence, and it may be that studio conditions are creating a sense of unease. The apparently hefty rough-cast plinth on which she leans is not as stable as its shape and texture might suggest. It is light enough to be moved quite freely and has been placed rather carelessly, so that it is not properly centred on its base and even overhangs

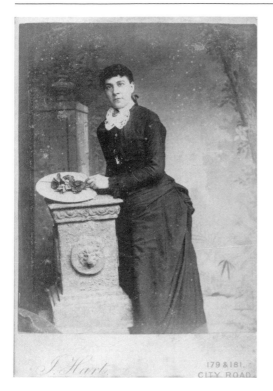

**Figure 139** Cabinet print;
John Hart, London

it on the side closer to her. In addition, when compared with the painted pillar on the backcloth, it seems to be leaning at a slight angle. As a result, the woman leans rather awkwardly with it.

One further factor doubtless adds to her discomfort. What at first glance may seem to be a tag or bow-end at the back of her neck, proves on closer examination to be an adjusting knob on some kind of stand. Although it seems a very late date for the employment of such a device, clearly a headrest is being used.

Figure 140 is a carte de visite, and it too suffers from a rash of pale spots. But the comparatively assured handling of the subject means that the blemishes are more readily overlooked. The young woman or (in view of the long plait) girl stands straight, with her body towards the table but her head partly and eyes fully turned towards the camera. In fact, the eyes probably look a little beyond the camera, to its left, which creates the air of thoughtfulness that was considered so characteristically feminine. Her right hand hangs down naturally, with no sign of tension in the loosely curled fingers. Her left hand rests lightly on the portrait standing on the table.

It is that portrait which arouses speculation. It could, in theory, be a studio prop, but it seems rather too personalized for that and the hand on the frame seems to suggest a relationship. Then there is a second picture,

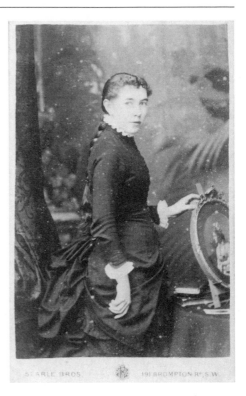

**Figure 140** Carte de visite;
Searle Brothers, London

apparently a carte de visite, on the table in front of the first, and this also shows a single subject. The temptation is to see the overall image as a mourning picture, paying tribute to a lost female relative. But the lack of any sign of crêpe casts serious doubt on the notion. If some accessories have a significance, then maybe all have, and it would be helpful to know what books are on the table. Unfortunately, however, no titles are visible.

The photograph was taken by the Searle Brothers of 191 Brompton Road, London. Pritchard first records them at that address in 1882, and they stayed there well into the next century. Nevertheless, quite precise dating of the picture may be possible, for the partly pictorial back of the mount includes a royal coat of arms, for which no warrant appears to have been granted. After the 1884 prosecution of A. & G. Taylor for unauthorized use of the royal arms, much greater restraint was shown by the trade, and it would have been a bold photographer who took liberties. There is therefore fair reason to suppose that the picture was mounted no later than 1884.

## The 1890s

Figure 141, a cabinet print, is the archetypal 1890s photograph. It achieves that distinction, quite simply, by being a head-and-shoulders vignette, a

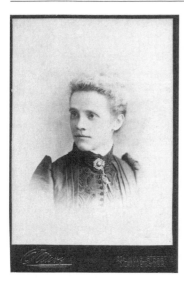

**Figure 141** Cabinet print;
Monsieur Sauvy, Manchester

style of presentation that results in excellent hair-sharp close-ups of people's heads. Unfortunately for family historians, this often leaves details of clothes to be imagined. In this case, though, enough of the costume is seen to provide a context for the face and help towards dating. The high collar and piecrust frill at its edge are typical of the times, as is the intricate work on the bodice. Although colours were frequently dark, there was often a great richness of decoration. But the detail that places the portrait at the beginning of the decade is the way in which the sleeves are set into the bodice, with a 'kick-up' effect. Such peaked shoulders were very much in vogue as the 1880s gave way to the 1890s.

The mount, too, is of its time. The card is black, with gold printing on the front and red printing on the back. The lettering below the image is impressed into the card, and a facsimile of the photographer's signature has been stamped in the bottom right-hand corner of the print. The bevelled edges are finished in gold. The picture, we learn, was taken at the Maison Française ('for Art Photography'), run by Monsieur Sauvy of Paris. The address of this very French studio, however, was 22a King Street, Manchester, and the mount was produced by W. Herrmann & Co. of Berlin.

Also printed on the back, beside a picture of a blazing star, are the words 'Electric Light'. It may seem rather a late date at which to be boasting of such lighting, since Britain's first electrically lit studio was opened in 1877, but the new method of illumination was taken up unevenly at first, with many practitioners reluctant to buy a generator. There were, presumably, enough old-fashioned premises in Manchester in the early 1890s to make modern lighting worth mentioning.

Figure 142 seems also to have been taken by electric light. There is no mention of the fact on the mount, but there is a bright reflection in the pupils of the young woman sitting on the left. Her well-lit face has a

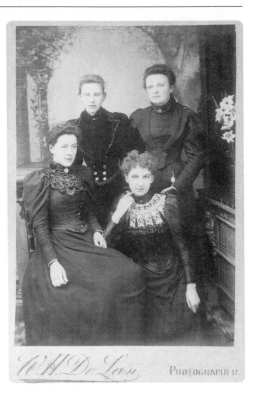

**Figure 142** Cabinet print; W. H. De Lan

*W. H. De Lan* PHOTOGRAPHER.

uniformity of tone, compared with the gentle shadowing that moulds the face of her companion on the right at the back; and this uniformity is another reason why some photographers clung to softer lighting.

This, too, is a cabinet print, and its mount is an example of the rather cooler approach to opulence that some designers adopted in the 1890s and which prevailed in the early years of the 20th century. The printing is impressed in gold on a cream card (now foxed) with gilt deckle edges. The back is entirely blank. Thus we know that the picture was taken by W. H. De Lan, but there is no address.

If the presentation of the picture is sober, compared with Figure 141, the studio background makes up for it. An archway, entwined with foliage, is created by a pillar on the left and, it seems, a tree on the right. Apart from the chair, two pieces of furniture are visible. One is carved and the other smooth, but both are very substantial. One of them bears a vase of real flowers.

In this setting are four young ladies who were probably friends rather than relatives. Some possible points of family likeness could conceivably be argued for, but since the four of them are so close in age it seems more likely that they were simply friends. Between them the young women give the welcome view of costume that Figure 141 denies us. The fashion emphasis is now on the top half of the body; and skirts, though full, tend

to be plain, without the crinoline hoops, frills, bustles and overskirts that marked out their predecessors of earlier decades. Bodices are tight, for in the last 20 years of the 19th century corsetry became an important contributor to the female shape. Collars are buttoned to the throat and one of the women has, if not the common piecrust frill, at least a touch of white at the neck and cuffs. Lapels, brooches, ruching, buttons and trimmed edges all play a decorative role. Lace is making its appearance, and by the end of the century will be seen in profusion on blouses.

But once again it is the sleeves that set the date. By the middle of the decade the peaked sleeves of the early 1890s had blossomed out above the elbow, while remaining tight below, to give the well-known leg-of-mutton shape. Since this was a style which – among the fashionable, at least – was fairly short-lived, and since these subjects are of an age where fashion might be expected to have some influence, the photograph may reasonably be assigned to the middle years of the 1890s.

## The Edwardian years

The Edwardian pictures selected for discussion are chosen for the problems they pose. Each is in postcard format, and each offers something of a puzzle.

Figure 143 shows three young men at ostentatious ease in the corner of a garden. The breeches of the central figure would have seemed curiously old-fashioned after the First World War, when plus-fours replaced such garments, except perhaps among the determinedly and self-consciously intellectual. The back of the postcard confirms that we should be thinking of the Edwardian period. The printed guidelines say: 'This Space . . . may now be used for Communications in the British Isles; also some Colonies and Foreign Countries.' This suggests a time around 1907, when postal regulations were becoming a little more relaxed, and this date is usefully supported by evidence within the picture. But the date is not the real question here. The difficulty lies in trying to work out the photograph's significance.

The group is seated around a small table or plant stand, on which stands a pot, against which is propped what seems to be a booklet. On the top page is printed:

> Ain't yer gwine to say 'How do?'
> Miss Victoria Monks

Victoria Monks was a popular music-hall performer. Today, her best-known song is 'Give my regards to Leicester Square'. She recorded 'Ain't yer gwine to say "How do?"' twice: once in 1906 and once in 1908. If, as would seem likely, the picture dates from the period of the song's success, then the initial dating of around 1907 would appear to be correct. But why

**Figure 143**  Postcard; photographer unknown

should these young men be sitting around a song sheet, the title of which is carefully displayed?

The words of the song do not seem to help. They tell the story of the errant Bill Brown returning after a long absence to a less than welcoming wife who locks him out. Whilst impressionable young men might choose a dashing prodigal as role model, the chastened Bill Brown is a figure of fun who seems altogether too querulous to qualify.

The possibility then occurs that this is a commercially produced promotional photograph, but the lack of caption and publisher's name argues against it. What is more, the fingerprints marking the sleeve, trousers and face of the man on the left may be evidence of an amateur processor, although professionals were also sometimes guilty of clumsy handling.

We can only conclude that these are admirers of Miss Victoria Monks and that they chose the song simply for its title, as a way of greeting the viewer. But what is the significance of the cycle clips, and why are the cigarettes unlit? Thanks to help from the British Music Hall Society, the picture proves satisfyingly datable, but any deep significance eludes their archivist as resolutely as it does the writer.

Figure 144 proves more tractable. 'This space for communication', printed on the divided back, assures us that the postcard is not likely to be earlier than about 1907, by which time manufacturers either outlined fairly complex postal regulations, as in the case of Figure 143, or opted for the simplicity seen here. The inappropriate and somewhat creased studio background suggests, without quite insisting on, the first 20 years of the century. But the vital piece of information, handwritten on the back, is

**Figure 144** Postcard;
photographer unknown

'Algy. First Prize North Pole'. Algy the Arctic Explorer, accompanied by a family of white teddy bears, has clearly won a fancy-dress competition.

On the face of it, home-made costumes and cotton-wool trimmings are not readily datable, but all becomes clear when we consider the criteria for fancy-dress success. A child wins by being cute or topical, or both. The perceived winsomeness of Algy is not easy to judge. He looks rather glum, though he is probably concentrating on appearing intrepid. But topicality is a different matter. From 1886 Robert E. Peary was involved in a series of Arctic expeditions. In April 1909, at his third attempt, he and Matthew Henson reached the North Pole. Despite a subsequently discredited claim by former associate Frederick Cook to have made the journey in 1908 (and despite the suggestion in the 1980s that navigational mistakes meant that Peary and Henson had in fact missed the Pole), popular imagination entertained no serious doubts about the success of the 1909 venture. Peary was hailed as the first man to reach the Pole (Henson and four Inuit companions being rather overlooked). It seems highly probable that Algy's triumph was a reflection of Peary's own; and that the fancy-dress competition was won, when the expedition was news, in 1909.

## From war to war

At this point, the discussion of pictures in pairs is abandoned in order to follow a series of wedding photographs through the first few decades of the 20th century.

The first example, Figure 145, is a large print mounted on stout board, at the bottom of which the unnamed photographer boasts, in small gold letters, of the king's patronage. The women's costumes show that the photograph dates from a few years before the First World War. There is a good selection of the large hats that became popular towards the end of Edward VII's reign, of which the most striking is worn by the woman standing second from left in the middle row. Such blouses as are on view lack the overhanging floppiness that was common until about 1908 (though one is just a little baggy) and there is no indication of the shocking V-necked garments of 1913 and later, so a date of 1910–12 should not be more than a year or two out.

The picture is full of opportunities for seeking family likenesses, particularly between apparent siblings, and includes such enjoyable details as the beribboned dog and the earnest boy in the sailor suit. It also encourages speculation about social class. Judging by facial resemblances, rather than by notions of who should be placed where in a wedding group, it is the men of the groom's family who, like him, are wearing frock coats.

**Figure 145** Mounted print; photographer unknown

Top hats and gloves are also in evidence. Lounge suits, on the other hand, seem to be the choice of the bride's male relatives. During these years, the frock coat was gradually giving way to the cut-away morning coat as genteel wear for weddings, whilst lounge suits were being worn with increasing frequency by the working population. It therefore seems likely that this wedding represents a socially mixed union, in which the bride is marrying above her class.

Figure 146, a postcard by Marie Podmore of Colne, Nelson and Barnoldswick, is set in the studio. It shows a smaller group, arranged on two levels and with a symmetry that is easy on the eye. The picture is from the 1920s, probably from quite late in the decade since the young man on the right looks only a very little older in a 1931 picture from the same source. Age, however, is always difficult to be sure about, and it is the women's clothes that, once again, provide the best evidence for dating. In parallel with skirts generally, the hemline of bridal dresses rose during the second half of the decade, but to calf rather than knee length. Although partly obscured by bouquets, the characteristic 1920s waistless look can be discerned in the dresses of both the bride and the bridesmaid on the left. The soft sheen of silk stockings can be made out, hairstyles are relatively short and dressed close to the head, and the bridesmaid on the right wears a cloche hat. Even the bride's veil is fixed across the forehead to give a line suggestive of the cloche. For men, by this time the lounge suit was quite acceptable wedding wear for middle as well as working classes.

Figure 147 was taken in the same studio just a few years later. The same

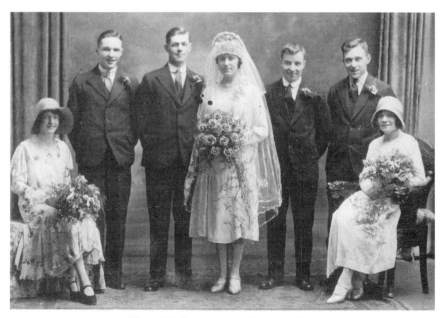

**Figure 146** Postcard; Marie Podmore, Colne

composition has been used, but the shorter bride makes for a slightly different effect. (To appreciate the grouping, imagine a line joining up the subjects' heads and identify the shape it makes. In this case, the shape is that of the top of a stylized heart, rather than the arc of Figure 146 or the interrupted parallel lines of Figure 145.) The neutral, slightly variegated backdrop has not changed and the curtains appear to be much as they were before, though this time they have been pulled a little further open to show a backcloth border and some panelling.

But the women's clothes have changed significantly. The bride's dress, in line with the prevailing fashion, is once again floor-length and the fall of the skirt over her hips suggests that waistlines have been reinstated. Hats have been dispensed with for the bridesmaids, and for all three women the line of veil or hair adornment runs across the top of the head rather than across the brow. Another common 1930s feature is the focus on shoulders and upper arms that is evident in the dress of the bridesmaid on the left, with its elbow-length cape. The function of men in such photographs is to complement rather than compete, and the dark lounge suits of three of them are quite predictable. The paler suit of the man on the left is rather less usual.

The last example, Figure 148, is known to have been taken in 1942, but had the date not been known, the men's battledress uniforms would have pointed firmly to the Second World War. Guards of honour were much in favour, the arches they formed being made up of swords, bayonets, truncheons, or even air-raid wardens' helmets. In this case, the groom was

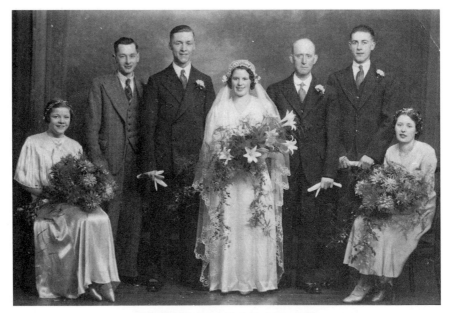

**Figure 147** Postcard; Marie Podmore, Colne

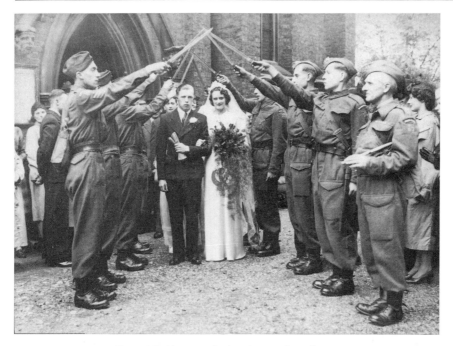

**Figure 148** Unmounted print; photographer unknown

in a reserved occupation and was attended by fellow members of the factory's Home Guard unit.

The design of brides' dresses was frequently affected by shortages arising from the war. Clothes were rationed and suitable fabric was not easily acquired. While this bride has a full-length dress, it will be noticed that the skirt is quite narrow. Full skirts and trains were luxuries that few could consider, unless an old dress was being recycled. Similar constraints often limited the length of veil, and new ones often fell no further than the shoulders. This bride has a much longer veil than many, but it is arranged so as not to hide her carefully waved hair. The permanent wave allowed some consolatory display in an age of austerity, and a second example can be seen amongst the bystanders, forming a marked contrast to the glimpses of sensible coats.

## The 1940s

Figures 149 and 150 do not at first glance strike one as war photos, though this is really what they are. But even at a glance there is no doubt that they are pictures of their time. The square-shouldered look of jacket and, more markedly, blouse, the knee-length skirt and the carefully 'permed' hairstyles speak clearly of the 1940s. The knitted clothes of the baby boy also cause no surprise. Knitting was not new, but in times of austerity it was a particularly useful way of providing clothes.

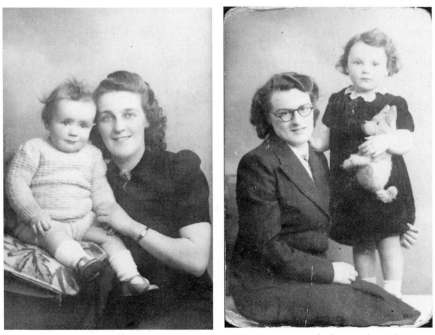

**Figure 149** Postcard; photographer unknown     **Figure 150** Postcard; photographer unknown

The pictures are of postcard size and one of them, Figure 150, is rather more dog-eared than the other. Nothing is printed on the backs, but this is not especially unusual. It is, of course, possible that the prints were originally slipped into fold-over cards on which the studio would have been identified. By the 1940s, the sort of neutral studio background that is seen here was standard, and pictorial backdrops, where they existed, were largely of the novelty seaside and fairground kind. These portraits look like a pair, and pencilled serial numbers (10885 and 10886) indicate that they were indeed taken on the same day in the same studio, even though the photographer is not named.

But none of this links the images to the war. Additional information is required, and that is the reason for the selection of these two photographs. The tendency throughout these pages has been to see photographs as an illumination of family history. Sometimes, though, the reverse is true and a knowledge of family history is needed to gain a full understanding of a photograph. That is the case here. Admittedly, a part of the story is told by a handwritten message on the back of Figure 150: 'To Darling Daddy / With all our Love / Mummy & Pamela / XXXXXX /April 1944 / Pamela 2½ yrs'. But an awareness of family history is called for in order to complete the tale.

The two women who took their children to a Croydon studio on that day in 1944 were sisters. Each had a series of shots taken of her child,

alone or accompanied. (The girl was more than a year older than the boy and was quite steady when photographed on her own.) Some of the day's pictures found their way into albums and others were exchanged, in very much the usual way. But there was also a more specific purpose behind the trip to the studio, for both fathers were away at war, and images of their children were to be sent to them.

There is a particular poignancy about Figure 150, for the little girl's father had not yet seen his daughter and he was not to do so until after the war had ended. More than one copy of the picture survives, but this is the one that was sent to him and which he carried around with him. The inscription on the back testifies to this fact, but so does the print's rather battered state. It is an unusual example of the damage to a photograph being a part of its significance. Other pictures from the series are in better condition, as are other copies of this one. But they haven't been to war.

# Bibliography

Books do not always fit easily into categories. For example, treatments of early photography may pursue their subject into modern times, and there can be some overlapping of interest when dating and interpretation are discussed. The categories below are therefore intended merely as a guide, and the works listed under a particular heading may also venture into other fields.

## History of photography

F. Dimond and R. Taylor, *Crown and Camera: The Royal Family and Photography* (Penguin, 1987)

A. Goldsmith, *The Camera and its Images* (Ridge Press, 1979)

J. Hannavy, *Fox Talbot*, 2nd edn (Shire, 1984)

I. Jeffrey, *Photography: A Concise History* (Thames & Hudson, 1981)

A. Linkman, *The Victorians: Photographic Portraits* (Tauris Parke, 1993)

G. MacDonald, *Camera: A Victorian Eyewitness* (Batsford, 1979)

S. Richter, *The Art of the Daguerreotype* (Viking, 1989)

## Popular photography – professional and amateur

B. Coe and P. Gates, *The Snapshot Photograph: The Rise of Popular Photography, 1888–1939* (Ash & Grant, 1977)

C. Ford (ed.), *The Story of Popular Photography* (Century, in association with the National Museum of Photography, Film and Television, 1989)

C. Ford and K. Steinorth, *You Press the Button – We Do the Rest: The Birth of Snapshot Photography* (Dirk Nishen, in association with the National Museum of Photography, Film & Television, 1988)

J. Hannavy, *The Victorian Professional Photographer* (Shire, 1980)

J. Hannavy, *Victorian Photographers at Work* (Shire, 1997)

E. Hostettler, *Island Women: Photographs of East End Women 1897–1983* (Dirk Nishen, undated)

## Identification and general dating

A. Linkman, *The Expert Guide to Dating Victorian Family Photographs* (Greater Manchester Record Office, 2000)

R. Pols, *Dating Old Photographs* (Countryside Books, 1993; Federation of Family History Societies, 1995)

M. Pritchard, *A Directory of London Photographers 1841–1908*, 2nd edn (PhotoResearch, 1994)

D. Steel and L. Taylor, *Family History in Focus* (Lutterworth Press, 1984)

## Dating by fashion

M. Ginsberg, *Victorian Dress in Photographs* (Batsford, 1982)

A. Lansdell, *Fashion à la Carte 1860–1900* (Shire, 1985)

A. Lansdell, *Seaside Fashions 1860–1939* (Shire, 1990)

A. Lansdell, *Wedding Fashions 1860–1980*, 2nd edn (Shire, 1986)

H. Worsley, *The Hulton Getty Picture Collection: Decades of Fashion* (Könemann, 2000)

## Interpretation

A. Briggs and A. Mills, *A Victorian Portrait: Victorian Life and Values as Seen Through the Works of Studio Photographers* (Cassell, 1989)

R. Pols, *Looking at Old Photographs* (Federation of Family History Societies, 1998; Countryside Books, 1999)

R. Pols, *Understanding Old Photographs* (Robert Boyd, 1995)

## Care of photographs

A. Linkman, *Caring for Your Family Photographs at Home* (Greater Manchester County Record Office, 1991)

E. Martin, *Collecting and Preserving Old Photographs* (Collins, 1988)

# Index

(Bold page numbers refer to illustrations.)